D0721548

PLAYING WITH SKETCHES

© 2014 Rockport Publishers

First published in the United States of America in 2014 by
Rockport Publishers, a member of
Quayside Publishing Group
100 Cummings Center
Suite 406-L
Beverly, Massachusetts 01915-6101
Telephone: (978) 282-9590
Fax: (978) 283-2742
www.rockpub.com
Visit RockPaperInk.com to share your opinions, creations, and passion for design.

All rights reserved. No part of this book may be reproduced in any form without written
permission of the copyright owners. All images in this book have been reproduced with
the knowledge and prior consent of the artists concerned, and no responsibility
is accepted by producer, publisher, or printer for any infringement of copyright or
otherwise, arising from the contents of this publication. Every effort has been made to
ensure that credits accurately comply with information supplied. We apologize for any
inaccuracies that may have occurred and will resolve inaccurate or missing information
in a subsequent reprinting of the book.

10 9 8 7 6 5 4 3 2 1

ISBN: 978-1-59253-861-4

Digital edition published in 2014
eISBN: 978-1-61058-945-1

Library of Congress Cataloging-in-Publication Data available

Design: Bryn Freeman
Cover Illustration: Melinda Beck
Cover Photo: Bryn Freeman

Printed in China

Rockport iPad App!
Use your iPad to preview, buy, and read
the latest and greatest from Rockport.
Visit the iTunes App store to download
your free App today!

ROCKPAPERINK
branding · typography · logos · color · design
management · design for change · posters · fashion
www.RockPaperInk.com

PLAYING WITH SKETCHES

50 CREATIVE EXERCISES FOR DESIGNERS AND ARTISTS

WHITNEY SHERMAN

Rockport Publishers
100 Cummings Center, Suite 406L
Beverly, MA 01915

rockpub.com • rockpaperink.com

CONTENTS

DRAWING CALISTHENICS / 50 EXERCISES

INTRODUCTION

I do love to draw and I'm sure you must, too; otherwise, why crack the spine of this book? Being an illustrator gives me good reason to say I love to draw, yet I also love design. Let me draw on graph paper, let me draw the label on this package or the cover of that book. I never questioned the melding of drawing and design, so it is no surprise that this book is for me to write and for you to read and use!

As a child, I always drew. During college, I took a lot of drawing courses. Although I had planned to major in graphic design, and had applied to schools for this—and been accepted—I was not a design student in the strictest academic sense, and I ultimately majored in photography. Soon after graduating, I found myself regretting my decision because I was now meeting many new people excited about and involved in design. And it was through them that I ultimately had my first education in design. They were my tutors, my mentors. Alongside this occurrence, and without a darkroom of my own, I turned away from photography and went back to drawing as a way to get ideas in real form. It was cheaper to draw on paper than to shoot and process film.

In my early professional years I held several positions integrating both graphic design and my drawing skills: greeting card artist, advertising art director, packaging designer, graphic designer for public television, and publications designer. Starting out professionally in a pre-digital world, it helped to be able to draw. Most design comps were made by hand. There was no output on a nice color printer. I could articulate concepts with marks that conveyed my ideas. These skills were assets to my job quests as well as to my personal, creative well-being.

Over time, I also became interested in teaching—that thing where you take what you know, analyze the "how" and "why," and synthesize the information into something transferrable, understandable, and inspiring. I've taught both design and illustration subjects for long enough that I have my own ideas about drawing—what it represents as an activity, what form(s) it can take, and what it means as a vehicle for communication.

I have taught design students who would say, "I can't draw," when what they meant was, "I can't draw like an Italian, French, or Flemish master!" This is probably true, and frankly it is not the real issue when it comes to the world of design. What is needed is good visual communication. Idea building through drawing can do this, especially if you accept a broad, maybe even different definition of drawing.

Please don't confuse this book with one that is meant to teach you rules. This book doesn't teach rules. It is calisthenics for your hands and mind, to help you break away from your norm to create a new way of thinking and mark making, and to give you permission to explore and make mistakes. Like the title of this book says, if you use this book, you will be playing while expanding your creativity and concept development through drawing.

In addition to the exercises, this book starts with a section on some artists and their resources. This section gives inspirational and practical information on their drawing tools, and insight into how they blend materials with their concept-making skills, augmenting the work by contributors to the book.

WHITNEY SHERMAN
Baltimore, MD

ANATOMY OF YOUR TOOLS

When it comes to drawing tools, your choices range from varying grades of hard to soft pencils; pens that require dipping or have ink encapsulated in them; brushes of all shapes and sizes; inks that have the sensuality of Sumi or the lacquer hardness of India; and a wide assortment of papers, from hot press to cold press, either loose or bound in a sketchbook. And that doesn't even begin to scratch the surface of nontraditional tools of found materials, the digital world, and more!

The tool you choose has a lot to do with the type of work you do and the temperament of your hand. After years of practice, you discover intuitively which tool feels right in your hand and which makes the marks that suit you best.

No one knows this better than Bill Turner, the Pittsburgh, Pennsylvania, web applications developer who loves to sketch and calls himself "a bit of a pen and notebook nerd." Turner had been fascinated by the weblog *Comic Tools*, where various comic artists were asked about the tools they used to create their artwork. He was disappointed when the interviews stopped, but later he was spurred on by Danny Gregory's book *An Illustrated Life*, where the same types of questions were being asked. "It showed me how many ways artists can express themselves with a wide variety of tools," says Turner, and so he started his own blog called *The Tools Artists Use*. The beauty of this site is Turner's interest in linking information about drawing tools. Within each interview, he tags specific tools mentioned by the interviewee, then adds a hot-linked chart at the end of the interview that links you to any other interview on his site mentioning the same tool as well as to providers when possible.

Here are four artists that Turner interviewed talking about the anatomy of their tools, followed by examples of five other artists whose work reveals something about their material and tool choices.

LAPIN

For this French illustrator, artist, and urban sketcher who alternately lives in Barcelona and Paris, a black ink pen has become his principle drawing tool. He has tried many brands, but he finds the Uni Pin 0.1mm is his favorite. It's indelible. He also uses red and blue Edding 1800 ink pens for drawing logotypes or lettering, and a gray Copic Multiliner. When it comes to liquid media, he uses a tiny, travel-size box of Daler Rowney fine watercolors (eighteen quarter pans) and Pentel or Kuretake water brushes. He carries two water brushes "to give enough autonomy for an intense sketchy day!" and four water brushes filled with liquid watercolors: yellow, blue, magenta, and orange. Lapin finds this arrangement useful, especially for night sketches. He occasionally adds colored pencils or some colored wax for emphasis.

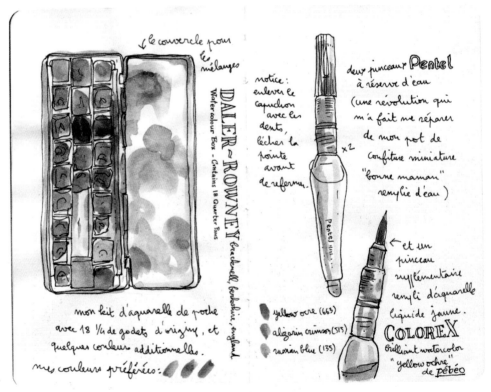

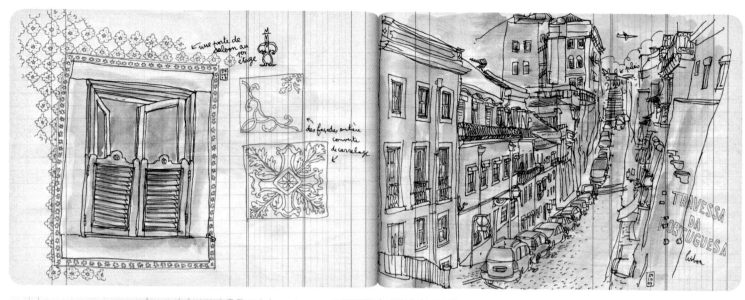

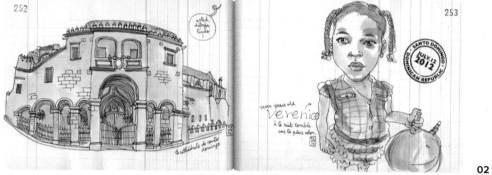

LAPIN

01 These two sketches from Lapin's daily blog show the tools he used to create his urban sketchbook imagery.

02 Lapin's drawings move between an emphasis on line and an emphasis on color, as seen in these drawings from Lisbon, Portugal, and Santo Domingo, Dominican Republic.

03 The structured page designs of Lapin's vintage accounting books impart a distinct contrast to his loose ink and watercolor drawings. The covers are also beautiful to look at.

02

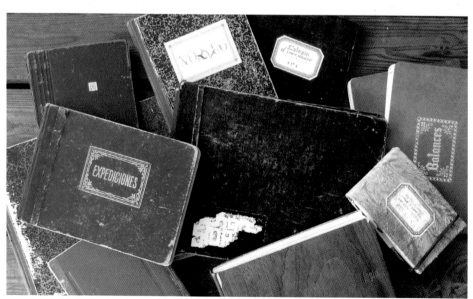

03

MIKKEL SOMMER

The Danish illustrator Mikkel Sommer is spartan when it comes to drawing tools and materials. Now living and working in Berlin, he makes his drawing philosophy and use of tools all about efficiency. To get the immediacy of line he prefers, he uses H2 or Prismacolor Col-Erase pencil for sketching, and B2 or B4 leads, usually in a mechanical pencil, for more accuracy during cleanup. "I can draw fast and dynamically with that," he explains. He also makes sure that his tools don't require much pressure—his wrist is on the weak side at times. Sommer also employs a cheap retractable Bic pen. "They have a nice, soft feel to them, but they run out of ink pretty fast," he notes. Although not adverse to pens, Sommer is very selective about what type of pen he uses. "Microns really cripple my lines, so those don't work for me at all; I've always liked the look of nib pens, but (they are) something I really need patience for," he says. All in all, Sommer is looking for speed and freedom.

A close look at Sommer's line work shows a vitality one can only achieve through tools that have tool-to-paper flexibility and allow him to work "as freely and as wildly" as he can with pencils and brushes. Currently, he is using a synthetic Da Vinci brush and thick ink to get the lines he wants. In Sommer's world, the deadline and type of project dictate how much digital finessing is done. To make adjustments to his line work, Sommer uses a Wacom tablet and Adobe Photoshop. Most of the values and textures in his work are made during the drawing process, giving him less to add during his coloring process. "Right now, doing comics, it's all about efficiency, producing pages fast that I'm still for the most part satisfied with," he says.

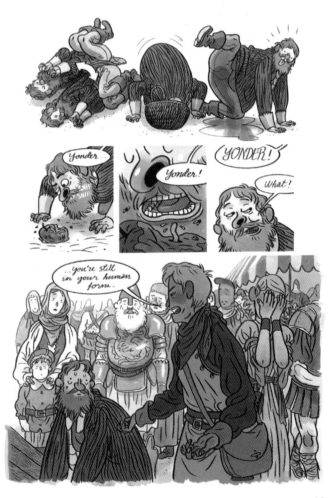

02

01

01 Mikkel Sommer's sketch titled *Jesus Look Alike* is an example of the speed and freedom so important to his work.

02 In this single page from Sommer's artwork for John Tierney's comic *Spera Volume II*, notice how he has colored his line work a reddish brown. This helps it sit back in the composition and blend into the color fields of the figures and background objects. The line work in this piece was drawn digitally.

03 These two examples of Mikkel Sommer's work titled *Katamari* and *Dog* show both his use of brush and ink and his digital coloring.

04 This side-by-side comparison of Sommer's illustration *One Cop* shows how retractable ballpoint pens are the right choice for line work that will eventually be colored. Sommer also strategically uses texture within his digital painting and pays special attention to not overworking his line work.

03

04

ANATOMY OF YOUR TOOLS

MARGUERITE SAUVAGE

Artist/illustrator Marguerite Sauvage is originally from Paris and now lives in Sydney, Australia. Her two favorite drawing tools are a 2B 3mm thin pencil and a 21-inch (53.3 cm) UX Wacom Cintiq display. She recently discovered the pleasure of working on a Cintiq screen, finding it to be a natural and fluid tool far surpassing any other graphic tablet given its direct-to-screen capabilities. The adjustable armature allows for many different positions of the display, from 10 to 65 degrees tilt, and rotates a full 180 degrees in either direction to enable drawing on different sections from different angles. Sauvage says, "Like my 2B pencil, my Cintiq is just an extension of my body now!" That said, she wants to emphasize that her drawings are never purely digital. Sketches and line work are always done in pencil and/or pen.

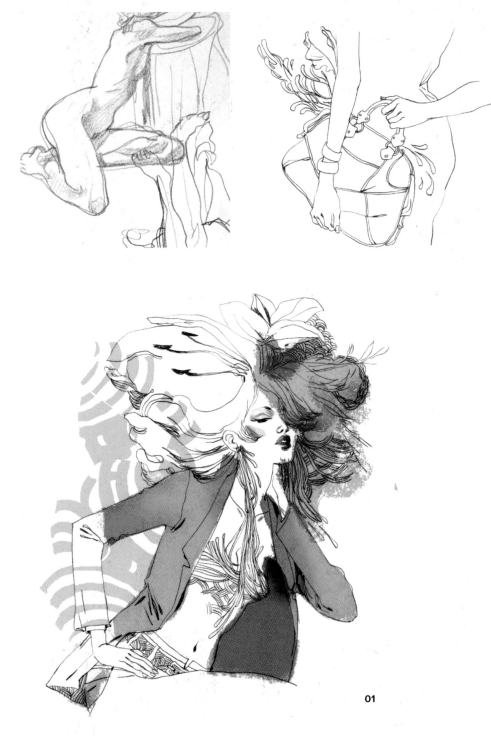

01

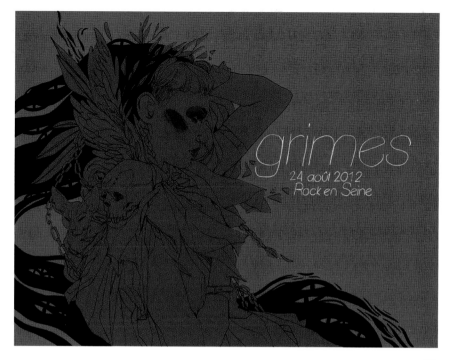

02

MARGUERITE SAUVAGE

01 These three examples of Marguerite Sauvage's line work show how she uses her sketchbook for traditional drawing practice: the intelligence of selective line work in the work produced in partnership with the pen manufacturer Bic; in her personal piece titled *Sonia*, printed for sale by Arte Limited; and on objects such as cushions by ClickforArt.

02 This digitally colored image, for the Grimes concert poster at the Rock en Seine Festival featured in the Paris Métro, shows how Sauvage's well-planned line work and use of selective color make this image graphically powerful, yet full of descriptive detail that comes to the viewer's eye on second glance.

03 These photographs give an up-close view of Sauvage's handwork as well as her tools. The works were produced in partnership with an artistic website sponsored by the pen manufacturer Bic. It's worth noting how confident her line is and how well her tools help control the quality and consistency of her lines. Colors from markers maintain vibrancy in her illustrations.

03

ANATOMY OF YOUR TOOLS

LUCIANO LOZANO

Luciano Lozano, a graphic artist and illustrator living in Barcelona, Spain, loves a simple black pencil. He also uses acrylics, pen and ink, watercolor pencils, and sometimes watercolor crayons. Lozano's palette is minimal except for a few colors that accent his muted palette. Although in the past he utilized digital techniques to create work, these days he is feeling a pull back to traditional media, to mark making and the evidence of the hand.

01

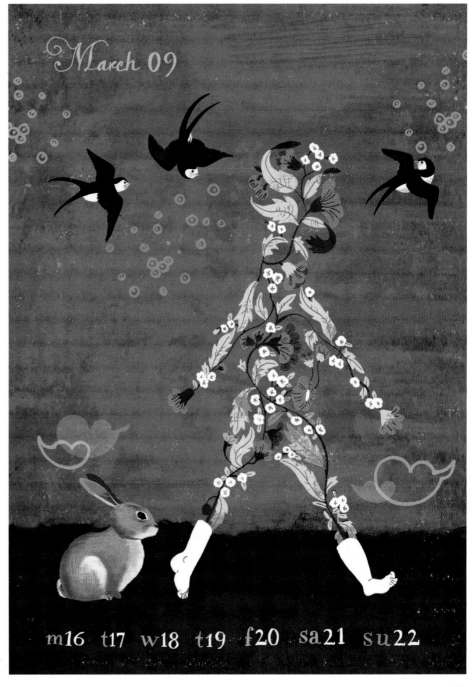

02

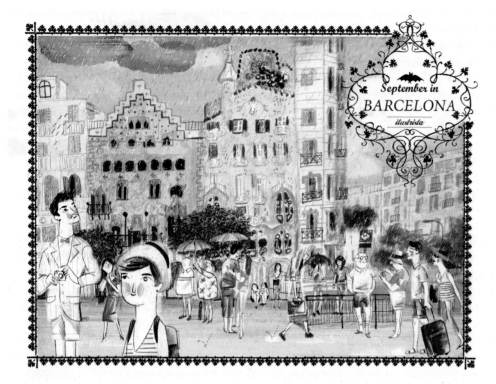

03

LUCIANO LOZANO

01 Luciano Lozano's sketchbook and quick drawing show an eye for sparse but well-designed compositions. This shows his use of a simple black pencil. It is playful, yet examines the relationship of figures within space.

02 *March* is a calendar poster created using Adobe Photoshop, but made to look like paint. The blend of texture in the background and flat colors for the smaller figurative details are harmonious in large part because of Lozano's use of a limited palette.

03 *September in Barcelona* has all of the immediacy of Lozano's sketchbook pages shown earlier.

04 In this image titled *Lhasa*, you can see evidence of Lozano's hand in the lines and textures. Tones, smudging, textures, and transparency are key elements of this emotionally charged image.

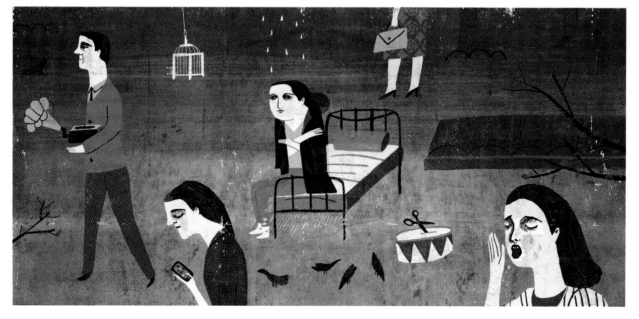

04

GUIDO SCARABOTTOLO

01 Guido Scarabottolo's charming and curious mixed-media painting, a calendar illustration, shows how fluid brushwork and a freedom of imagination are the best tools to have. "I always use very simple tools: a pencil, a pen, or a brush. In this case, I used a brush pen with ink cartridge for the main figure," Scarabottolo notes. The small ducks at the bottom are made by pencil, and the birds placed between the figure's horns are scans from a color painting by Cristina Piccioli, "a longtime friend and charming artist."

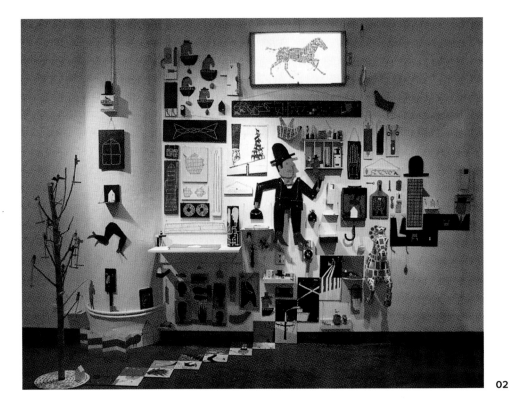

02

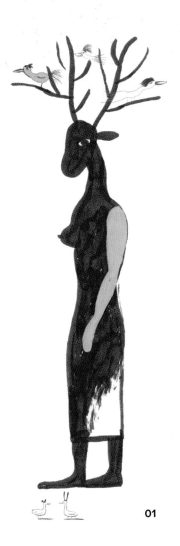

01

ANDRÉ DA LOBA

02 Illustrator André da Loba calls himself an artist and a reluctant poet. This exhibition installation, titled *Cabinet*, contains works on wood, papier-mâché, metal, and cardboard. The materials were salvaged and were selected to reference his relationship with his adopted city of New York. "I would go out on recycling day and find cool pieces of wood, metal, and lots of cardboard. I found real treasures," says da Loba.

MARTIN HAAKE

03 Martin Haake's sketchbook reveals high-energy use of colored pencils. Although Haake doesn't use colored pencils as his primary material for his illustrations, they are excellent tools for making quick, expressive marks.

MATT LYON

04 Illustrator Matt Lyon created this piece titled *DeSalvo* as a self-portrait originally made in 1993. It contains a layering of materials and line work. Lyon's graphically driven white acrylic paint line work mimics fog or clouds, and obscures his face. His use of graphite on paper, a black-and-white photocopy, tracing paper, and tape achieves an ethereal effect. Pen and ink line work helps set the shoulders of the figure on the ground.

CAROLINE TOMLINSON

05 This collage by British illustrator Caroline Tomlinson, titled *Prom*, was created digitally. She used vintage photographs and postcards for the key elements, including the beautiful handwriting that is used as a texture. Hand-painted and hand-drawn marks are made, then collaged into the piece. Tomlinson tries to make sure her images don't look too digital. Adding just enough hand-painted elements helps prevent that.

der Bademeister

03

04

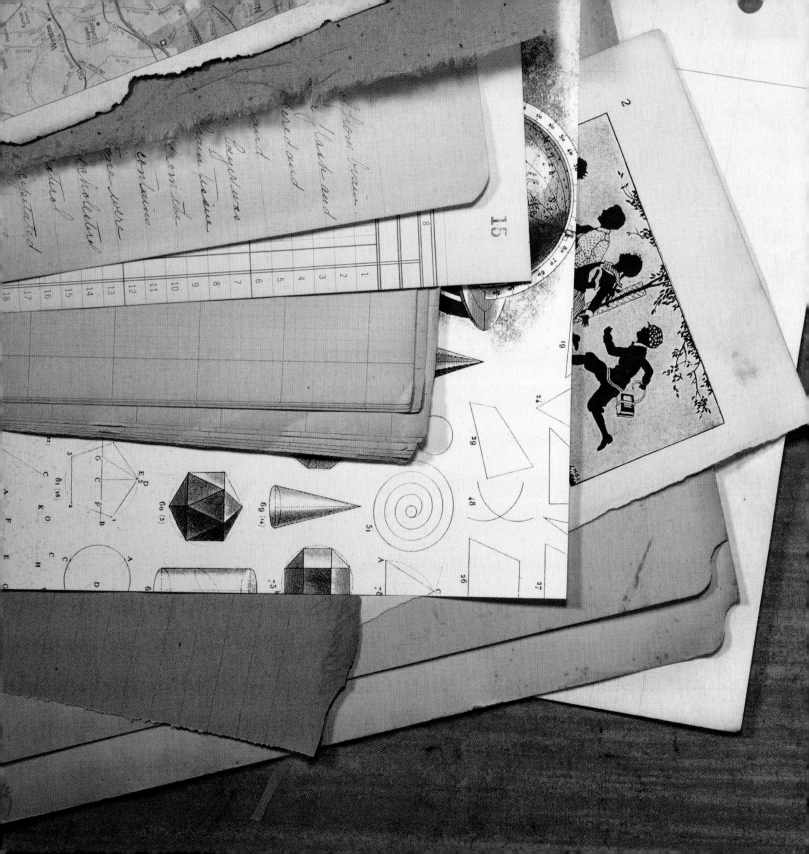

DRAWING CALISTHENICS

50 EXERCISES

01. PARALLEL LINES

When I started art school, I had a Yale-trained drawing teacher, Michael Economos, who was persistent and demanding. Even before entering the class, I knew what I was in for. His reputation for hard work and relentless exercises preceded him. And so here is his first exercise—the one that we did for almost four weeks, the one that made us mentally salivate for an organic shape to draw, the one that made me a better drawer!

MATERIALS

18 x 24 inches (45.7 x 61 cm) pad of high-quality drawing paper

Sharp #2 pencil

STEPS

1 Starting at the top of the page, carefully draw a single line from left to right. Make the line as straight as you possibly can. If it's not straight, don't worry; this will improve over time.

2 Next, directly below it, draw a line parallel to it. Make the space between the lines about the same size as the thickness of a pencil line. Third, draw another line parallel again, but make the space between line two and line three slightly larger than that between line one and line two.

3 You can see the pattern emerging. You will now draw line four, then five, and so on until the entire page is covered top to bottom.

4 Concentrate on the spacing between the lines as well as the straightness of the lines. This exercise can be taxing and you can soon feel bored, but if you break through that wall, stick with this exercise, and practice it for a long time. The improvement in your hand control will be noticeable, and mastering this is a precursor to mastering tonality.

VARIATIONS

- Scale the paper sheet size down to 9 x 12 inches (23 x 30.5 cm), then move up to a larger size paper.

- Do this exercise using a coil rather than a straight line, and rather than increase the space between the lines, increase the height of the coil.

- Use your sketchbook to make mini versions of this exercise.

- Do the exercise as a daily calisthenic before starting work.

The following are examples of work that utilize parallel lines as a visual device.

01 The premise of drawing parallel lines can be translated into other types of marks, including coils, zigzags, and waves, each increasing in height and distance from each other. Once hand control is mastered, you have the ability to decide how precise or imprecise your use of parallel lines will be.

01

02

MARTIN HAAKE

02 Martin Haake economically uses ruled paper for the background and painted lines on the figure to produce an effect that mimics the crosshatching style normally found in an etching. Haake's line work simultaneously describes hair and cloth pattern through a variety of line weights and colors. Cutting the shapes and reassembling them in a collage gives a distinct edge to each element and counterpoint to the hand-painted lines.

ALICE POTTER

03 This sketchbook image of a polar bear by Alice Potter playfully interprets the icy coolness of arctic life through her white-over-blue crosshatched line work.

03

04

05

GUIDO SCARABOTTOLO

04 *Lame Chair* was created for a children's book published by Topipittori in Italy. Scarabottolo drew "blindly" through carbon paper, so there was an element of surprise to his process.

05 *Shame*, by Guido Scarabottolo, rendered in ballpoint and digital, was produced for a calendar published by Doctors with Africa CUAMM and art directed by Giovanna Durì.

06 This watercolor by Guido Scarabottolo is a personal piece. He uses "inadequate tools"—in this case, a longhaired brush he bought forty years ago—to draw on an old school book. Scarabottolo's exercise with tools and marks is made more interesting by embedding the figure within the background.

06

02. RANDOM TEXTURES

The *Merriam-Webster's Dictionary* defines the word calisthenics as "systematic rhythmic exercise that promotes strength, endurance, and flexibility by placing regular demands on the cardiovascular system." If you think of your drawing skills as the heart of your image-making life, then this exercise will make perfect sense. Strengthening your manual dexterity will improve your confidence and ultimately appear in the quality of your marks. You will have the endurance to maintain a consistent line quality and the flexibility to easily change your line work, bringing variety to your image.

MATERIALS

Ebony Jet Black pencil

Hard pastel

Fine-tipped marker

Medium-tipped marker

Brush-tipped marker

Crow quill pen

Charcoal pencil

6H graphite pencil

STEPS

1. When testing out tools to see the results of these marks, first grid off small boxes on a sheet of paper and limit your marks to inside the box.

2. Once you have discovered tools that are effective for you to use, use individual sheets for mark making and work in a diligent but more uninhibited way, making larger and smaller marks.

3. Work until you have filled a sheet. This will loosen your hand to making marks that are more directed and purposeful.

02

01

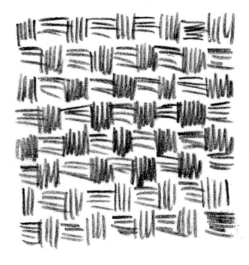

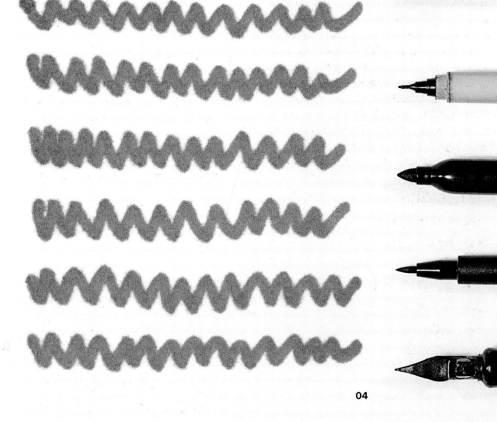

03

04

EBONY JET BLACK PENCIL

01 The Ebony Jet Black pencil is among the best pencils to make a rich black mark.

HARD PASTEL

02 Hard pastels rather than soft pastels can give more control in your mark making, yet even though it is compressed, there are certain limits to making clear, well-defined marks.

FINE-TIPPED MARKER

03 A fine-tipped marker is perfect for more technical or detailed drawings.

MEDIUM-TIPPED MARKER

04 A medium-tipped marker will make a bolder mark and is great when you need to fill in solid areas.

Make a large number of random marks and scan them to create a library of marks for later use. They can be printed out and drawn on, used in a collage, or used as a digital layer.

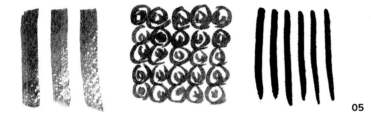

05

BRUSH-TIPPED MARKER

05 A brush dipped in India or Sumi ink will produce a mark with great variety, depending on the amount of water mixed with the ink, the thickness of the brush, or the "attack" of the brush to the paper. Brush-tipped markers are extremely portable, and they produce marks that simulate a real brush in ink, but they do not have as much range.

CROW QUILL PEN

06 This fine-tipped pen makes a wonderful variety of mark weights, but it requires constant dipping to renew the ink.

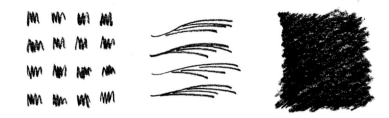

CHARCOAL PENCIL

07 Charcoal pencils give a little more control and are somewhat less messy than vine charcoal, but you will have less control than with a graphite pencil.

6H GRAPHITE PENCIL

08 Graphite pencils come graded from H (hard) to B (soft) with HB at the center of this scale. A 6H pencil is the hardest lead available. It does not smudge easily and never produces a pure black mark, but a 6H pencil stays sharpened longer than a softer lead pencil does, allowing you to draw small details and fine lines.

07

08

03. **FROTTAGE** (RUBBINGS)

The first known use of the word *frottage* as an art form of the Surrealists was in 1935, yet the technique is also a popular method for taking rubbings of headstones, relief carvings, and other ornate and decorative surfaces.[1] As an art practice, Max Ernst (1891–1976) used rubbings in his collages. The technique of reproducing a texture or relief design by laying paper over it and rubbing it with some drawing medium, such as pencil or crayon, is not widely used today, yet the Austrian American artist Nicola Ginzel has taken the form to visually exciting levels. Ginzel uses many materials in her ethereal textured art. For her, frottage is a primary element of her work and directly integrates the textures of her own making into her other works.

To create her unique textures, she embroiders paper ephemera, such as printed forms that have graphic elements such as lines, rules, and typography, thereby combining the old with the new. Ginzel notes, "The hand is evident upon things mass-produced and machine made," with craftsmanship being a by-product of her meditative, intuitive approach.

To begin this exercise, find a number of surfaces that have texture and are varied for you to use as the basis for a drawing. To do frottage in the Ginzel method, you will need embroidered surfaces. If you do not sew or are not interested in learning, look in vintage shops for embroidered surfaces. Other interesting surfaces are wood or metal letterforms, coins, floor and table wood grain, architectural surfaces like concrete, stone carvings, pressed tin panels, or metal openwork.

MATERIALS

Ground materials (For surfaces outdoors, bring a surface to kneel on during the rubbing and scissors for removing overgrowth. If cleaning stone surfaces, use a soft brush or sponge; never use sharp tools on carved stone.)

Masking tape

Rubbing paper (recommended: plain white paper, newsprint, butcher paper, rice paper, lightweight Pellon fabric)

Rubbing media (recommended: crayon, graphite stick, charcoal block)

Fixative (use non-yellowing, workable fixative for dry media like charcoal or graphite)

STEPS

① Acquire your ground materials.

② Tape paper down to the ground surface before beginning the rubbing.

③ Begin rubbing gently in a circular motion until the character of the ground material shows through. You can make areas of the rubbing lighter or darker to bring dimension to the image.

④ Remove the rubbing from the ground and fix the rubbing, then decide whether you want to add a medium to the rubbing, such as white paint or chalk.

⑤ Use the rubbing as the basis for a new drawing or as a collage element.

⑥ Consider using the same rubbing paper on several ground surfaces to create an overlapping effect.

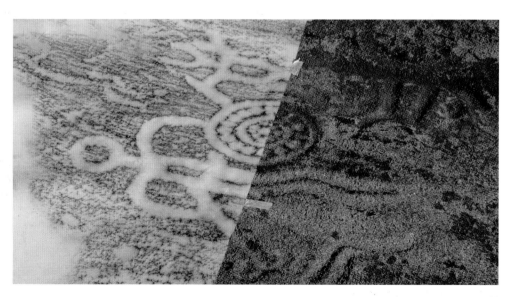

01 Frottage of a rock carving from an archaeological site in Hede, Kville parish, Kville hundred, Tanum municipality, Bohuslän, Västra Götaland county, Sweden.[2]

02 Nicola Ginzel's graphite frottages of embroidered ephemera.

02

TIP *When working outdoors, cut paper to size and carry it in a cardboard tube. Always fix rubbings in a well-ventilated space immediately after making them. Crayon rubbings don't need to be fixed, but if done on Pellon, the rubbing should be heat-set by covering with foil and pressing on low heat.*

[1] www.merriam-webster.com/dictionary/frottage.

[2] http://en.wikipedia.org/wiki/File: Dokumentation _av_h%C3%A4llristningar_-_frottage.JPG.

04. **DRY BRUSH**

Dry brush is achieved when rapid, short, straight, or circular strokes are made with a brush containing little paint or ink. Brush experiments will vary depending upon your brush and media type as well as other variables. For this exercise, select a few of the brush types and media and experiment in different combinations to see which suits your interests.

American artist Andrew Wyeth is known for his use of dry brush, or scumbling, as a technique in his tempera paintings. The lack of water in the paint gives his work a unique dry appearance that replicates the environment he observes. It is a technique that creates discernable texture as well as soft transitions. This exercise gives you two ways to use dry brush: 1) to create an archive of textures, and 2) to create customized paper.

Here, landscape painter Paul Ryan demonstrates five dry brush effects based on specific brushes. He uses dry brush in his paintings when he wants to achieve a convincingly dry surface like walls or hard ground. "The process of dry brush is more like drawing than painting for me. There is a hard attack of the tool to the surface and the way you hold the brush is more like the way you hold a pencil or pen when sketching," he says. Create a digital archive that can be colorized and printed for a unique drawing surface or used in digital image compositions.

BRUSH TYPES

Flat shader brush

Japanese calligraphy brush

Round 0 brush

Stencil brush

Windsor Newton #10

VARIABLES

- What type of brush is used?
- What type of media is used (e.g., India ink, Sumi ink, gouache, watercolor, dyes, acrylics)?
- How much media is in the brush?
- How diluted is the media?
- How absorbent is the paper?
- What is the paper surface like? Smooth? Coarse?
- How much pressure is applied?

06

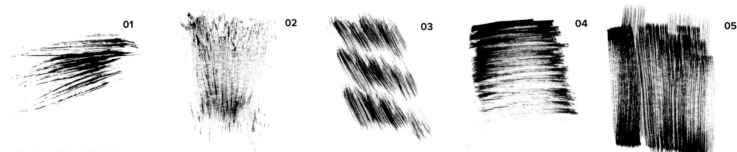

01 **02** **03** **04** **05**

07

SARA BARNES

06 The second part of the exercise is about creating your own papers to draw on, or use in a scissor drawing (collage) or reductive drawing (étrécissement)—a valuable and easy way to personalize your work. Collagist and Maryland Institute College of Art (MICA) grad student Sara Barnes knows this because that's what she does: She paints paper, and at times even hand makes her own paper. Dry brush is one of the techniques she uses to customize her own paper. "By using your own papers, you'll get the perfect color or texture in your images," she says. Barnes advocates experimentation, whether by using different techniques or materials or by adding one color lightly over another. Scan your experiments and store them as digital archives for future projects.

MARTIN HAAKE

07 The dry brush effect can be seen in this piece by British illustrator Martin Haake. This kind of effect can be achieved directly in the original art, by scanning dry brush marks that are later brought into an image digitally, or by using digital paint tools to create the textures.

WHITNEY SHERMAN

08 This acrylic and graphite painting is my psychological self-portrait for *Dialog: The Fine Art of Conversation*, edited by Mark Murphy. I used a dry brush to create visual nostalgia of midcentury advertising and suggest the textures of grade-school playgrounds.

09 The dry brush effect in my illustration titled *Isolation* is created digitally in Adobe Photoshop. Using a digital media can give you the ability to make a dry brush effect as coarse or as fine as you desire.

08

09

01 Japan brush using ink.

02 Windsor Newton #10 sable brush using ink.

03 Stencil brush using ink.

04 Round 0 brush using ink.

05 Flat shader brush using ink.

05. FUMAGE (SMOKE DRAWING)

Invented in 1936 by Wolfgang Paalen, the Austrian-Mexican painter and theorist, fumage was a later addition to the collection of Surrealist games that sought to transform automatic writing into forms of drawing and painting. Using the smoke from a kerosene lamp or candle, Paalen "drew" directly onto a piece of paper or canvas. Soon after, he used the loose ethereal forms as a basis for his paintings, moving quickly from dreamscapes to what has been termed "cosmic abstraction."[1] So influential was his work that it was later adopted by Salvador Dalí. Both Paalen and Dalí's elongated forms reveal the influence of the technique.

In the 1940s and 1950s, Paalen's art played a major role in changing the conception of abstract art, especially in New York during the formative years of Abstract Expressionism. Through his writings and paintings, self-published in his art magazine *DYN* (1942–1944) and in *Form and Sense* (1945, edited by Robert Motherwell), Paalen cemented his role as a visionary and pioneer of modern art.[2]

Fumage is not a frequently used drawing technique, but when used it can produce a subtle and mysterious effect. One notable twentieth-century fumage artist was banker Hugh Parker Guiler, spouse of diarist Anaïs Nin. Under the name Ian Hugo, he began his art career in the 1940s, and created many book covers for Nin's writings.[3] Currently, French artist Raoul Gardette has taken the technique in a new direction, in both process and delivery. Gardette has been using the online marketplace Etsy to sell his limited-edition fumage drawings. He also has incorporated stencils, adding some control to the image-making process while keeping the smoky edge of traditional fumage. "My idea was to use fumage in a figurative way, but to allow it partial freedom to drift," he notes. Making a fumage drawing in the traditional or Gardette method (outlined below) requires few materials, but attention to safety is paramount.

MATERIALS

Cardstock

Craft knife

Slender stick candle

Candleholder

Lighter or matches

Paper (not too thin)

Fixative

STEPS

1 Make drawings on fairly thick cardstock, cut them out, and turn them into stencils.

2 Place a candle in a candleholder, light the wick, hold the blank cardstock and stencil together at the edge in one hand, then move the cardstock and stencil back and forth over the candle below. Move the card and stencil quickly over the candle, allowing the smoke from the candle to pass through the stencil.

3 Get the basic figurative shape of the stencil to show on your cardstock, but allow random bleedings of smoke to occur as well. Traditionalists position the candle about ½ inch (1.3 cm) below the paper, and keep it moving to avoid burning the paper. They also experiment with shifting the angle of the paper to increase or decrease the density of the smoke markings—long wicks make fluid marks; short wicks make darker marks.

4 Some fumage drawings are not worth keeping, but others produce imagery that one could never even dream of making in a traditional drawing sense. Those are the ones Gardette keeps.

5 The drawings need to be fixed fairly quickly. Even breathing on them can lose part of the drawing.

Gardette has also experimented with mixing media. "Smoke with charcoal, smoke over watercolor and acrylic dilutions, and overlaying with oil-based glazes. All have different qualities," he says.

[1] *"Paalen-Archiv Berlin," www.paalen-archiv.com/en/biografie/ wolfgang-paalen-01a.php, accessed November 3, 2012.*

[2] *Ibid.*

[3] *"Fumage," http://en.wikipedia.org/wiki/Fumage,*

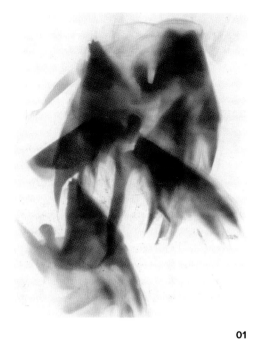

01

02

03

RAOUL GARDETTE

01 *Ascending Angels*

02 *Green Subs no. 3*

03 *Heavy Horse no. 1*

04 *Divers Combination no. 2*

05 *Nocturnal Skyline,* Fumage and charcoal

06 *Hares Boxing,* Fumage and oil glaze

05

04

06

TIP *Use different-sized candles to create a variety of palettes, and use a kneaded eraser to remove areas of smoke. Make sure you have nothing flammable nearby. Always use fixative in a well-ventilated space.*

06. ÉTRÉCISSEMENT (REDUCTIVE DRAWING WITH ERASURE)

Reductive drawing helps you think less about lines and more about values, shapes, and tones. The examples in this exercise use either charcoal or powdered graphite erased, scraped, or otherwise reduced back to remove tone. In some ways, the process has connections to the rubbings exercise earlier in this book. To create a reductive drawing, use a piece of compressed charcoal or brush on powdered graphite to cover your paper with a tone [01]. Decide whether the tone is even or modulated before you begin. Next, use your hand, a paper towel, or a chamois cloth to blend the charcoal into an even tone [02]. Experimenting with these tools is important so that you know which combination works best for you. To reduce the tone, use a pink pearl eraser, a vinyl eraser, and a kneaded eraser to sketch in the basic shapes of your objects, and apply different pressure to get a subtle range of values. Other tools for lightening your toned ground are paper stumps, razor blades, steel wool, fine- to coarse-grade sandpaper, and electric drafting erasers.

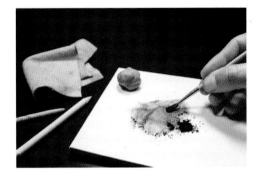

01

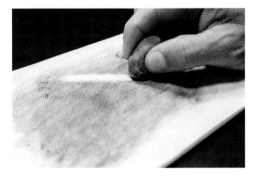

02

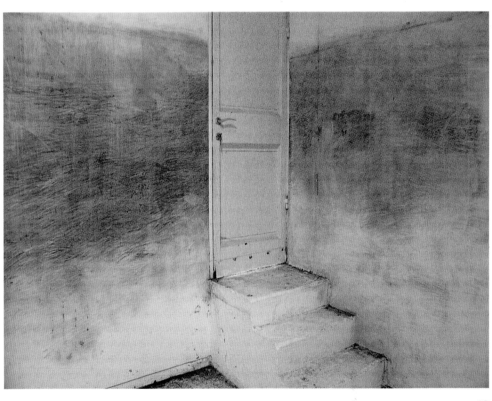

03

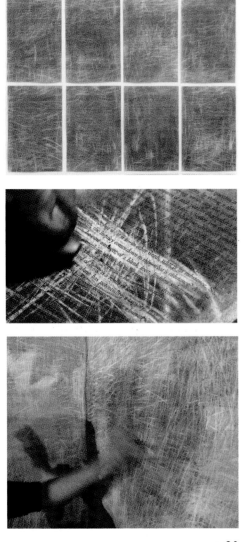

04

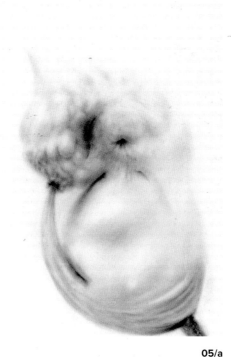

05/a

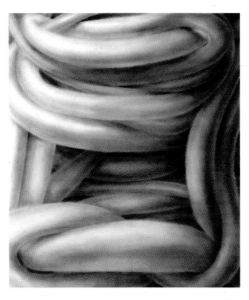

05/b

LEZLI RUBIN-KUNDA

03 Originally from Canada, now working in Israel, multidisciplinary artist Lezli Rubin-Kunda makes drawings that are site-specific "framing and heightening of the ordinary." Her work shown here, *Drawing in an Empty Space*, made with natural charcoal on the walls at Nachshon Gallery, Kibbutz Nachshon, Israel, uses the reductive process to reveal "cracks and nail holes, peeling layers of paint, and invisible spider webs" that all emerged from the wall's surfaces. Many other of her reductive work on walls appears in her recent book, *Walls I Have Known...and marked...and drawn on... and incised into...and erased....*

04 Rubin-Kunda's reductive drawings titled *The Consolation of Philosophy 2*, part of a series of drawings using books on classical Western philosophy, use graphite and erasures to cover an entire book on Hegelian thought. The pages are installed in a grid on the wall. The drawings, she says, contrast "chaos-markings, hesitations, and dynamic energy" with a "dry systematic linear layer, sometimes exposing, sometimes obliterating the text underneath."

DEBORAH ZLOTSKY

05 New York artist Deborah Zlotsky uses a reductive process in her drawings. Her small-scale images *Hunnyschneckle* [a] and *Vilosopher* [b], each around 5 x 7 inches (12.7 x 17.8 cm), have the visual power of monumental imagery. For Zlotsky, the softness of the drawing's tones match the forms rendered. She calls powdered graphite "endlessly malleable" because she can spread, paint, blow, erase, wipe, and smudge the medium. Zlotsky uses as many tools as she needs to adjust the tones to make the forms emerge. "For me, working reductively or subtractively is closer to sculpting or painting than to drawing," she notes. Zlotsky's reductive drawings are about altering relationships in a process of accumulating, assembling, revising, abrading, and repeatedly repainting that blur our sense of time.

1 | BACK TO BASICS MATERIALS, SHAPES, AND PATTERNS

MATT WOODWARD

07 The sheer scale of these drawings (25 x 9 feet [7.6 x 2.7 m]) is impressive. While retaining the softness and visual suggestion of reductive drawing, Matt Woodward's *Milwaukee Avenue II* series also embodies the precision that is at the heart of architectural forms, the subjects of his drawings. In fact, Woodward notes that the more the graphite powder gets into the paper, the more he has to "rip the paper in order to carve it back out." Because of this, his large-scale work takes on a three-dimensional, sculptural quality—an apt quality for this subject matter.[2]

OLENA KASSIAN

08 Olena Kassian also uses powdered graphite on Mylar. These are the media of choice when a delicate gradient of grays is desired. As Kassian sees it, "The willingness of these materials to move from strength to subtlety has enabled me to explore relationships of light and space, edge and surface, movement and atmosphere, a language to access emotion." Her works *Fling* [a] and *Jump, diptych* [b] are large scale and figurative, reminding the viewer of dancers.

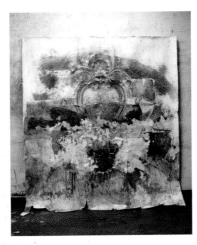

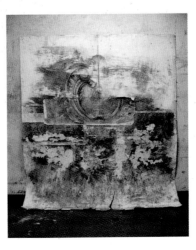

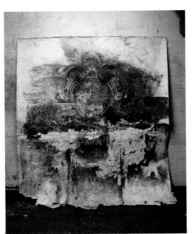

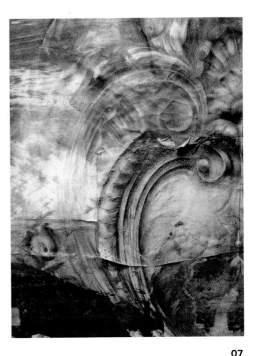

07

08/a

1 http://telavivartdesign.com/2010/12/lezli-rubin-kunda-wall-of-perpetual-html, accessed February 20, 2013.

2 http://dailyserving.com/2011/11/fan-mail-matthew-woodward,

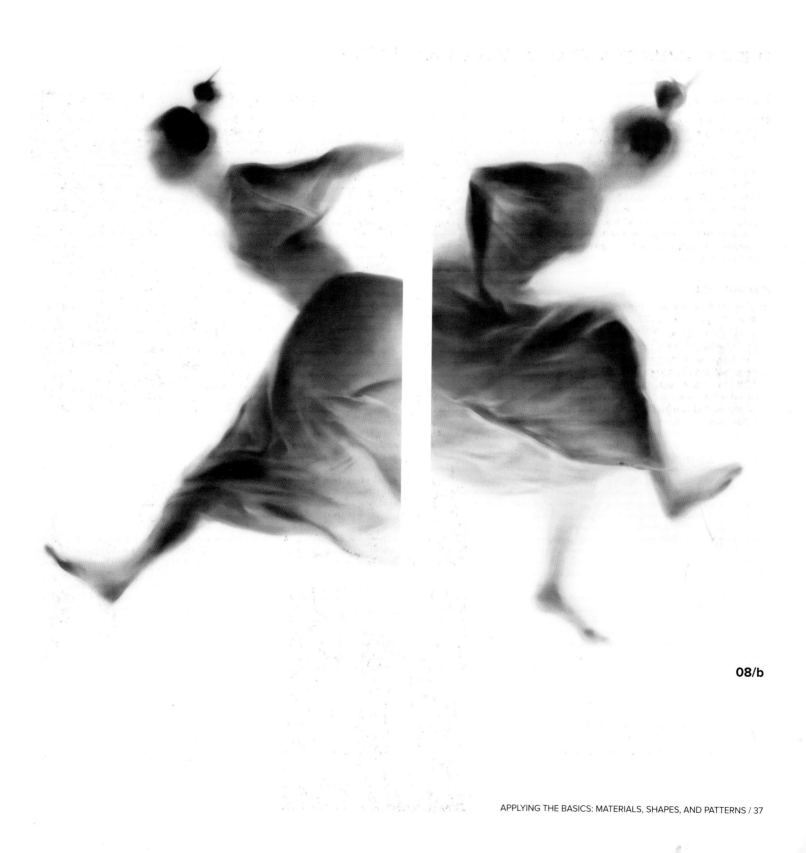

08/b

07. ÉTRÉCISSEMENT (REDUCTIVE DRAWING WITH PAPER)

In the 1950s, Belgian artist Marcel MariÎn first began working with reductive collage, or what the Surrealists called *étrécissement* (pronounced etra-sees-mont). MariÎn used the technique when he first practiced art because he felt he could not draw. His example shows why, if you feel drawing is not your strongest suit, you may want to consider making images using étrécissement. The process is called a reductive method because an existing image is cut in to reveal another image beneath it, or because a blank sheet is cut to create a specific shape and the negative space is the image. When tearing rather than cutting with scissors or a knife, the method is called "excavation." Étrécissement is also referred to as "décollage."

MATERIALS

Magazines

Scissors or craft knife

Blank paper

STEPS

1 Select several pages from a magazine.

2 Layer one image over another, then use scissors to cut away parts of the top image. Or cut out sections of several sheets without thinking about how the pages will go together to capture more of a surprise element during assembly.

3 Notice what is revealed underneath. Consider moving or shifting the top layer to find a pleasing or an unexpected combination. This can be done with two or more layers of images.

4 To make the simplest form of étrécissement, use a blank sheet of paper and only cut a shape from a sheet of paper

PAPER CUTTING

Closely related to étrécissement is the practice of cutting paper. It is a historic and time-honored art tradition, and the oldest example surviving is a sixth-century symmetrical circle from China.[1] Within a century, the practice had made its way all over Europe, specifically to Switzerland and Germany in the sixteenth century, where it is called *Scherenschnitte*. It was then later brought to America in the eighteenth century, predominantly to Pennsylvania's German communities. Each culture has its own term for paper cutting: *papel picado* in Mexico, *kirie* in Japan (*kirigami* when there is folding added), *sanjhi* in India, knippen in the Netherlands, *ka ti* in Turkey, and *vytynanky* (pronounced *wycinanki*) in the Ukraine, to name a few. The noted Danish children's book illustrator Hans Christian Andersen was known to make impromptu paper cuttings as he told his stories.[2] Today it is no longer a purely decorative art form; artists Kara Walker and Béatrice Coron and street artist Banksy use the form as a vehicle for social and political commentary.

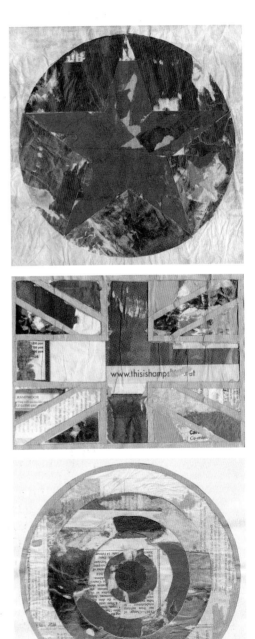

01

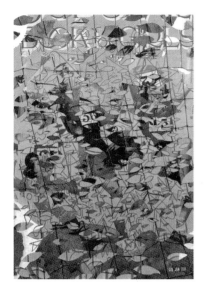

02

180

03/a

03/b

04

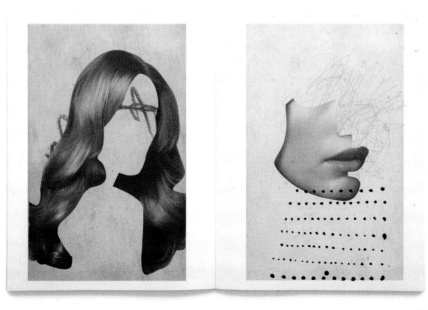

MATT LYON

01 These three décollage designs use scraps of newsprint and paint to assemble three striking designs: a star, a Union Jack, and a target.

02 Matt Lyon's piece, simply titled *23 January 2011*, is from his daily drawing series and follows the technique of étrécissement. The design was created from a brush pen drawing that was used as a template to digitally cut out of a vintage copy of *Book for Girls*. After being cut, a found image was then rotated and positioned under the cover to show through the holes. Bits from the cutting were repositioned on top. Some of his other designs have been inspired by the décollage techniques of Jacques Villeglé and Mimmo Rotella.

DANIEL HOROWITZ

03 Daniel Horowitz used a variety of found ephemera and blank or painted paper to make these images, titled *Drawing of the Day 180* [a] and *Drawing of the Day 166* [b], from his book *365 Days*.

CAROLINE TOMLINSON

04 Seasoned British illustrator Caroline Tomlinson creates work for clients like Sephora that is typically bold and striking. These pages from her sketchbook, titled *Rayban Fashion Icon*, use décollage and some handwork. She notes, "I love playing a game of seeing how much I can remove from a photograph for it to still make sense to the viewer. It is a fine line. Take too much away and it can become an unrecognizable something! But if I get it right, key elements can be removed and I am left with something far more interesting and ownable." Tomlinson feels she can sometimes spot an image and know instantly whether it will work better and look more interesting with elements removed.

[1] Joseph Needham, *Chemistry and Chemical Technology* (Cambridge, UK: Cambridge University Press, 1974).

[2] http://papercutting.net, accessed November 5, 2012; and Tifffany Schroeder, *Paper World: Presenting Paper Art from around the World*

08. **COLLAGE** (ADDITIVE DRAWING)

Collage artist/blogger Sara Barnes knows the elements of collage don't adhere to the rules as traditional rendering does. For her, drawing in collage starts by mapping her shapes in pencil, then she continues refining and articulating the shapes with scissors. For her, both pencil and scissors become agents in the drawing process. Additionally, the paper selection plays a part in how "rendered" the shapes appear.

She notes, "If you use paper, your images will be flat and graphic. If you use magazine pages, of course the image will have more tone. I start by doing a simple line drawing that I use as a map. This gives me an idea of how the final image will look, and also helps me think about how to actually build the image." She does not glue anything down until she is sure that it is the proper size, color, and placement within the image "because you can't erase collage." Barnes emphasizes, "Think beforehand about how the image will be built."

She recommends three things to make the process of collage building go smoothly:

1 Work in layers, starting with the most basic shapes and eventually refining the image with details.

2 Use small pieces of tape or sticky tack as a nonpermanent way to arrange shapes and try different colors and papers for your image before you make it permanent.

3 Use a glue stick or double-sided tape to ensure that large pieces of paper will lie down flat and make the final piece look smooth.

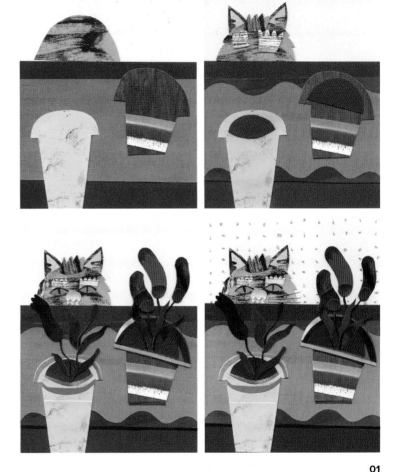

01

TIP *Use bookbinding glue and a paintbrush to glue down smaller pieces of collage. For very small details, tweezers are very helpful.*

02

SARA BARNES

01 Sara Barnes shows four steps to building a collage, starting from back to front. Barnes added the cat's face and the flowers in the vases as one of the last steps. She then used embroidery thread to create a decorative background for this piece, called *Spy*.

02 Part of Barnes's vast scrap collection and her favorite collage tools.

DANIEL HOROWITZ

03 Daniel Horowitz used a variety of found ephemera and traditional collage methods to make these images for his book *365 Days*.

04 Daniel Horowitz combined Japanese newspaper and vintage printed ephemera with a pencil drawing to create these images for *365 Days*.

04

03

If you can't find paper you like, consider making your own! As the author of BrwnPaperBag.com, Barnes has an abiding interest in paper and knows the value of making her own. She also promotes getting collaborative with collages. Her *Collage Scrap Exchange*, a part of the Brown Paper Bag site, invites artists to gather up their scraps and trade them with someone else. The results are unexpected because you are forced to use what you get—all of it!

Using some of the earlier loosening up techniques in this chapter (Dry Brush and Random Textures), you can create a wide range of colors and surface textures as elements. Make sure you test out your tools on the paper surface before beginning, because certain paper surfaces are less receptive to pencils, pens, and paint. Creating your own papers for collage (by painting paper, or even making paper yourself) is a great way to personalize your work. Experiment with different techniques or materials, such as monoprinting, to give it texture. After you are done, you can always scan the papers and store them to work in digital collage as well.

A collage can also blend your "scissor drawings" with drawing using pens and pencils. Consider adding colored paper specifically placed on the page before drawing on it. Illustrator and educator Jaime Zollars does this in her gallery work to enhance her black-and-white pencil drawings. She began using this method to speed the process of adding selective color to her predominantly black-and-white drawings. She advises, "Let the shapes you cut define the shapes of the things you draw. Collage first, concept next."

 TIP

Use a hole punch to quickly make a bunch of circles, then use the paper you punched as additional texture and layer paper behind it.

05 Zollars uses small Color-aid paper pieces to build her drawing surface before starting her detailed pencil drawings. She likes the consistency in color it provides and feels the matte surface is ideal for holding details in graphite.

05

09. ENTOPIC GRAPHOMANIA

Many of the Surrealist games can seem quaint to artists today. In the case of entopic graphomania, the artist was to discover the impurities on a piece of paper, place dots on the impurities, and draw connections between the dots. This was considered an automatic drawing, one originating from elements out of your control. With paper surfaces improved, the abandonment of control in this exercise is removed and the exercise is in need of revamping. Certain practical aspects of this game do live on, engaging you in new ways of thinking and discovering an artist previously unknown, as I did with Ithell Colquhoun. Colquhoun was an artist, poet, novelist, and magician born in India of British parents in 1906. She was widely traveled, distinguished in her day, and part of the Surrealist group in London before being ousted from the group in 1940 for her interest in the occult. But before she was cast out she subscribed to and used many of the Surrealism techniques as starting points for her paintings. "In 1939, she began to experiment with decalcomania and other forms of automatism. That is, using various methods of applying paint randomly to her canvas or paper and then interpreting the resulting stains and marks. Automatism was important because it enabled her to make connections between surrealism and the occult," writes Richard Shillitoe.[1] Colquhoun's preference was to draw straight lines between the dots; other Surrealists preferred curved lines.[2] For this exercise, either or both are allowed.

These exercises will help you think outside your comfort zone and willingly engage in randomness to take your work a few steps further. This Surrealist game is probably one of the most obscure methods of automatic drawing and is very hard to do in its original form given the advancements in papermaking. Because of that, this exercise adapts the basic creative idea behind the original drawing game to make it an interesting exercise; perhaps it will even cause you to think of other alternatives. Following are updated directions for this exercise and suggested materials and tools, followed by directions on how to do it. The Surrealists argued over the correct order of connecting the dots, but you can make your own choice!

To substitute for paper with impurities:

- Use vintage paper or "green" paper made of recycled materials.
- Use junk mail, carry-out menus, or similar bulk mail.
- Use a printed-out email no longer than one page.
- Use a page from a book.

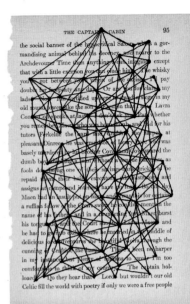

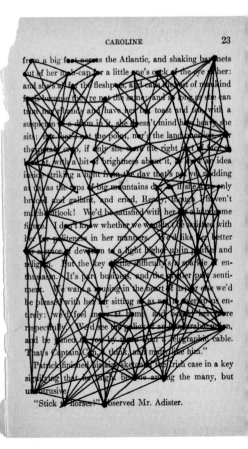

[1] Richard Shillitoe, www.artcornwall.org/profile%20ithell%20colquhoun.htm, July 2006.

MATERIALS

Colored pencils

Roller-ball or brush pens

Graphite pencils

Thin-gauge tape

STEPS

1 Using vintage paper, you will locate discolorations in the paper, place dots on these locations, and connect them with straight, curved, wavy, or zigzag lines.

2 Using junk mail, carry-out menus, or other bulk mail, look for all of the punctuation in the texts, place a dot on them, and connect the dots, making the same choices as in the previous variation.

3 Using a one-page email or a book page, choose one letter or all of the vowels, place a dot over them, and connect. Remember to vary your choices of straight or curved lines and discover which you like best.

4 To take any of these updated variations further, choose areas between the intersections of the lines and fill them in with black or a color. Each paper surface will yield a different set of shapes. Take it another step further by drawing something representational on top of the page abstraction, or scan your entopic graphomania drawings and print out numerous sheets on which to draw. These pages can also be folded and bound to make a unique sketchbook.

01

01 These variations of the original Surrealist game show how you can adapt it to immerse yourself in an almost meditative process of mark making. On one page, a dot is placed over each letter *m*, and then the dots are connected; on another page, a different letter is selected. Decide whether you make the connecting lines dense or sparse. You can also make the connecting lines curves or weave the line from point to point like you are weaving or stitching the line through the dots.

10. TRACINGS

Each section in this book is meant to facilitate your interest in drawing, but at times direct instruction is not the most informative method. It is observing and experiencing that will inspire you. In my freshman year in college, I had to write a report on a contemporary artist for my art history class. Being an unorganized freshman, I waited until the last minute to go to the art history department to sign up for one of the artists our teacher placed on an approved list of names. By the time I arrived, there weren't many names left, and so I chose the friendliest-sounding of what was remaining: John Wesley. Although I was aware of many Pop artists, I hadn't heard of Wesley, but I decided I was lucky, because Wesley worked in New York City, near where my family lived. After arrangements were made, I was on my way into the city and to Wesley's studio. At eleven o'clock I arrived to find a man dressed all in black—black cowboy shirt, boots, and hat—holding a beer. On entering the studio, his first words were, "Do you want a beer?" He was extremely cordial, especially so considering his studio day was being interrupted by an uncultured seventeen-year-old. I must have amused him enough, or he was gracious enough, that he give me four hours of his time, loads of information, a photographic print of one of his paintings, and a handful of glass-mounted slides of his work—some his only copy—on the promise that I'd return them after writing my report.

This story has meaning to this exercise because what I learned that day in John Wesley's studio was important to how I thought about making art. Wesley's studio was full of paintings stacked in the central room and in anterooms, and the walls were lined with sheets of yellow tracing paper typically bought in rolls and used by architects—exotic compared to the tracing pads I was familiar with. On the sheets of yellow tracing paper were outlines of single images that were then seen repeated on canvases he had already painted. Stunned, I asked him if he traced. Up to that time, tracing was, I thought, what you did if you couldn't draw. He said, "There's no such thing as cheating in art." Although his response challenged my perception that tracing equaled cheating, it also confirmed that the rules didn't apply, and in that moment all preconceptions I had changed.

In the years that followed, I learned about tools like the Artograph machine, which allows you to project an image onto a sheet of paper, enlarge or reduce the image, and trace what you wished of it. Illustrators and designers used this method as a way to get to a final image in the shortest amount of time. Fast-forward to today and "trace" is a function in Adobe Illustrator, and one can use layers in Adobe Photoshop to trace over shapes or line work. The take-away in this exercise is that the idea of tracing is as new as it is old, and the images included in this exercises are meant to exercise your brain to think of how you might use tracing as a method for expanding your idea of drawing.

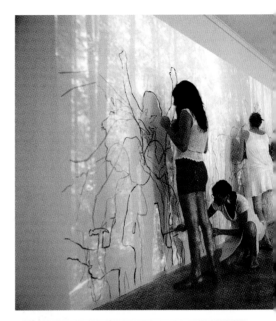

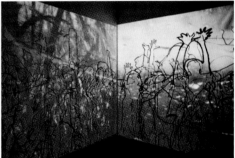

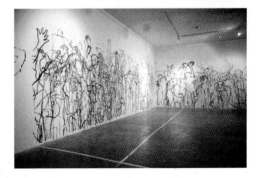

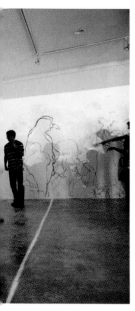

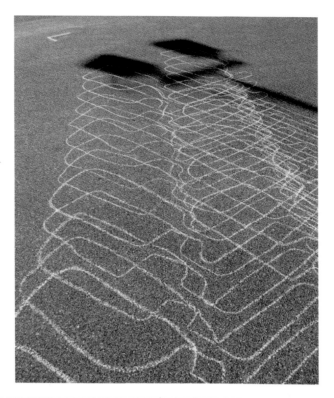

01

ANALOG ANALOGUE

01 Analog Analogue, an art team that formed during their graduate studies at Florida State University in Tallahassee, Florida, is comprised of Marnie Bettridge, Chalet Comellas, Jay Corrales, Tyler Dearing, Johnson Hunt, Christina Poindexter, and Echo Railton.[1]

For their 2011 installation, Cave Paintings, the collective engaged gallery-goers in the process. While videos of vegetation were projected onto several walls, the artists traced their silhouette, to leave evidence of themselves on the walls. As the evening progressed, ink marks were darkened. At the very end of the exhibition, the videos were turned off, and only the tracing marks of the gallery-goers remained, giving a clear impression of the activity in the gallery throughout the run of the show.

CLAIRE ZITZOW

02 Claire Zitzow traces shadows and videotapes the process. Zitzow says she is interested in "built environments, wilderness areas, and ecological conflicts in the United States which seem abstract and distant in our social psyche." Tracing shadows is her way of showing time and marking space. *Shadow Tracing 10* is from the series *Shadow Tracings* made between 2006 and 2011. As she traced the shadow's movement every three minutes, the systematic performances were filmed in DV and HD video, with still digital and medium-format photographs.[2]

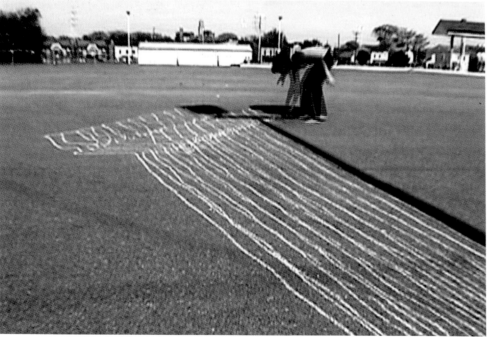

02

[1] *http://analoganalogue.org/#item=cave-paintings,* accessed February 1, 2013.

LITA JUDGE

03 Lita Judge's relationship to tracings is both personal and historic. While cleaning out her grandmother's attic one day, she came across a dusty box full of yellowed papers—tracings her mother was familiar with but had thought were long gone. Inside the box, Judge discovered envelopes with post–World War II German postal marks. Inside the envelopes were the tracings of feet made by families in need. "Some were cut out in the shape of feet, others were drawn on paper, tracing the outline of an entire family's feet, the littlest in the center with larger tracings growing outward like rings on a tree stump," says Judge. Both simple and profound, the tracings take on individual personalities through the choice of paper, the marking tool, and personal notations. Like so much that starts out as practical, these unique tracings are elevated to the status of poignant memoir.[3]

TONIA DI RISIO

04 Tonia Di Risio's installation *Tracings* has been adapted to a variety of specific spaces and their histories. On the walls, Di Risio traced silhouettes of domestic period furniture, including Queen Anne–style chairs, tables, and accessories, and then painted-in the shapes.[4]

03

[3] http://tracings.litajudge.com/stories1.html, accessed February 5, 2013.

04

11. DOODLING AND MINI DRAWINGS

The twentieth-century definition of the word *doodle* is "a casual scribble done without aim or intent."[1] Knowing that, the definition in the seventeenth century, "a foolish person, a simpleton, one who goes about things aimlessly," gives perspective on why doodling has historically been thought of as an undesirable activity. Maligned for decades as a sign of low intellect and lack of focus, doodling is finding its legs in the world of memory, problem solving, and creative brainstorming. In March 2011, visual thinking and information design consultant and author of *The Doodling Revolution* Sunni Brown presented at the TED Talks. She describes doodling as a way to "process information and solve problems" and as an "incredibly powerful tool" that assists us in processing things "when information density is high." As Brown puts it, doodling is a "portal to higher levels of visual literacy."[2] Doodling mimics many of our early drawing activities that are precursors to our understanding the world around us. This exercise aligns itself with Brown's perspectives and argues for doodling as a path toward broadening the definition of drawing in general. There are many ways to support your ability to doodle, but here are a few ways others enhance their ability to doodle:

- American artist Peter Max places pads of paper at key spots in his studio to make it easier to doodle and his record ideas while talking on the phone.

- British artist Paperchap uses his commute between Shoreham-by-Sea and London's Victoria Station to doodle on his daily paper, making commentary and just being playful.

- American illustrator Kate Bingaman-Burt chronicles her daily purchases. She has been doing this since 2006.

- WeeWillDoodle, an artist collective based in the Philippines, uses the power of community to energize their doodling.

- Bill Ford offers a monthly doodling class at the the Yeiser Art Center, exposing children in western Kentucky to the art.

- Doodlers Anonymous is a website run by concerned doodlers OKAT and Hugo Seijas. They describe their site as a "permanent home for spontaneous art." They blog, perform interviews, run themed submission challenges, and post amusing thoughts on paper. Their philosophy promotes the need to draw, sketch, and doodle—constantly and habitually—"even when we should be sleeping."

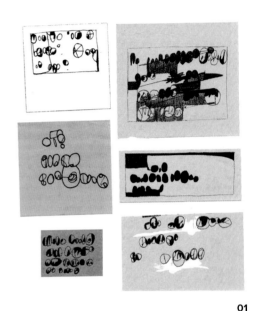

01

02

[1] Collins English Dictionary—Complete and Unabridged (*New York: HarperCollins Publishers, 1991, 1994, 1998, 2000, 2003*).

[2] *Sunni Brown*, Doodlers, unite!, *http://blog.ted.com/2011/09/23/doodlers-unite-sunni-brown-on-ted-com, TED Talks/TED2011, Long Beach,*

PAUL RYAN

01 Doodles come in figurative, decorative, and abstract forms. Landscape painter Paul Ryan is a compulsive list keeper. These doodles were made on old notes after they were no longer needed.

MAI LY DEGNAN

02 Mini drawings are another variation of doodling. Drawn within the squares of graph paper, this image, called *Pugs*, by MICA MFA in Illustration Practice student Mai Ly Degnan, features several hundred individually drawn pugs in different postures. Making this mini doodle has spurred Degnan on to think of other things to confine inside graph paper squares.

ANIL MISTRY

03 British artist Anil Mistry doodles during his travels between work and home. When not working as a creative director on big brand projects, he spends his time creating paintings and screen prints, and of course doodling.

MATT LYON

04 Graphic artist and illustrator Matt Lyon has had his work appear in *Juxtapoz* magazine, *SoulPancake*, *Playful Type 2: Ephemeral Lettering & Illustrative Fonts*, *IdN* magazine, *ReadyMade* magazine, and more. His doodlings are as diverse in topic as they are prolific. He lives and works in London; has exhibited in China, Sweden, Italy, and Spain; and runs the studio C86.

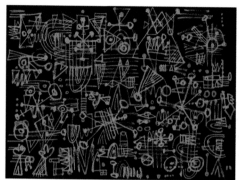

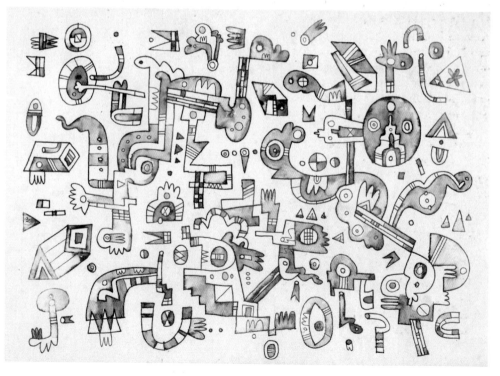

03

04

MATT WILLIAMS / UBERKRAAFT

05 Matt Williams, aka Uberkraaft, is serious about doodling. "It's fairly normal for me to start drawing without a plan or composition set in my head. I tend to start on paper and keep erasing and changing bits until I'm happy," he explains. This piece is called *Painted Trojan*.

06 Williams really likes to switch between analog and digital "so I keep a bag full of pens at the ready," he says. "Right now I'm hooked on classic Rotrings (isographs), and I'd never be without a bunch of Posca paint markers." His piece, *Won Wabbit*, is made using Posca paint markers on carved wood.

07 Sketchbook cover for Umbraco, a web content management systems company, by Williams.

RICHARD KUOCH

08 Artist, illustrator, animator, and graphic designer Richard Kuoch, originally from Auckland, New Zealand, but now based in London, doodles to work out the high-energy characters he designs under the name PodgyPanda.

06

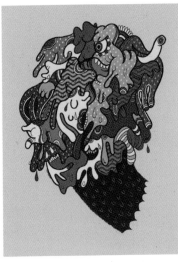

05

07

08

FLORA CHANG

09 Taiwanese illustrator Chang has doodled for many years. Her website, Happy Doodle Land (http://happydoodleland.blogspot.com), speaks volumes about her love for doodling.

10 These wood buttons using Chang's doodles are 1 inch (2.5 cm) in diameter. Chang uses a woodburning tool with a tiny fine-burning tip to individually create the thin line art. The buttons were later turned into rings for sale at local art fairs.

11 Chang's hand-painted doodle bowls are wooden bowls rescued from antique shops and thrift stores. She paints them with acrylic in different colors, distresses the surface by hand, and then doodles on top with black graphite pencil. Chang seals the surface with coats of matte varnish, and finally adds a coat of beeswax, making the bowls not food safe, but for decorative purposes only.

SCOTT BAKAL

12 For the background in the illustration *Float*, Scott Bakal features mini drawings of sea life that create texture and impress us with their delicacy. Bakal derived this part of his painting from drawings in his sketchbook.

09

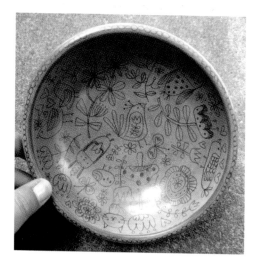

10

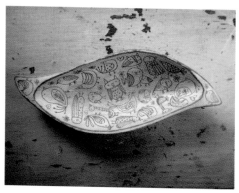

11

12

12. STICKY NOTES QUILT

This exercise is an adaptation of one game the Surrealists played, called the Exquisite Corpse, but differing from the exquisite corpse in one important way—the drawing is constructed using sticky notes. By using sticky notes, the image is seen as it is constructed, rather than hidden and later revealed as with a typical exquisite corpse game. And because the notes are adhesive but nonpermanent, you can create your quilt virtually anywhere.

The technology for adhesive was invented in 1968 by Dr. Spencer Silver. It wasn't until 1970 when Dr. Silver's 3M colleague, Arthur Fry, used the high-tack, low-adhesion material to create a bookmark for himself that the Post-it, as we know it, was born. Since that time artists have used sticky notes for more than a quick, handy note. Using them spurs collaboration and promotes healthy competition and purposeful rifting. In the example shown here, the quilt is built with multicolored notes using medium-tipped marker.

MATERIALS

Sticky notes

Medium-tipped markers or medium of choice

STEPS

1 Find a clear wall to do this project. This is an ideal way to start this exercise and it allows for expansion of the shape, but if the wall surface doesn't easily accept the sticky notes, you can start on a large sheet of paper and then tack the finished exercise to the wall.

2 Use a square sticky note of any size to start. Begin by marking anywhere, but be sure to create your drawing to touch only the right and bottom edges of the paper. You can use one or many paper colors.

3 Each day, add another blank note in either direction and continue drawing. Do this exercise yourself or invite friends or colleagues to join in.

4 As the drawing grows, so does the opportunity to grow the drawing's complexity. In a shared studio or office space, the sticky note quilt will eventually fill an entire wall.

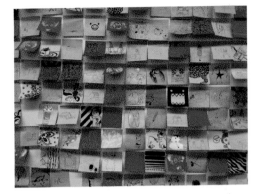

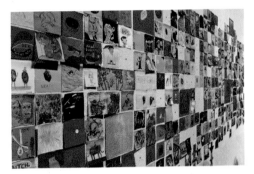

01

MARK TODD & ESTHER PEARL WATSON

01 Artist and illustrators Mark Todd and Esther Pearl Watson curate an annual sticky note exhibition, usually based on a theme of their choice. This variation produces a conceptually connected rather than physically connected quilt. The media used on each square is varied, giving the exhibition surface depth and interest.

VARIOUS ARTISTS

02 International and domestic MICA MFA in Illustration Practice students Jun Cen, Joshua Heinsz, Lisk Feng, Valeria Molinari, Eduardo Corral, Sarah Jacoby, Tong Su, and others created this group sticky note quilt.

JORGE COLOMBO

03 Another variation of the wall quilt is quilting in a blank sketchbook. Illustrator and filmmaker Jorge Colombo used mini-sticky notes while on the phone to draw quick sketches of heads.

TIP

Consider experimenting with different-sized notes, or arranging the colored squares to make an image along with the image of the line drawing.

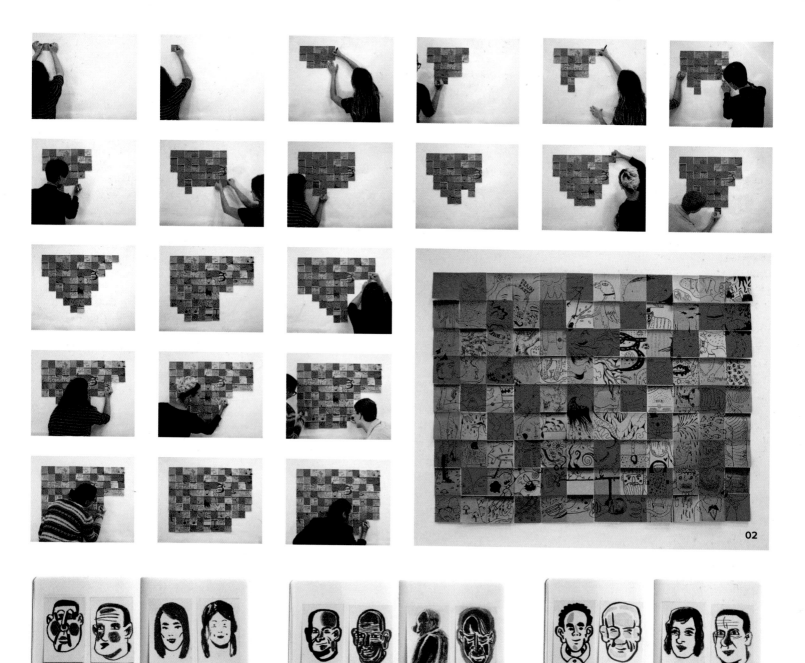

13. MAKE A PATTERN

Back in 2008, Julia Rothman made a splash sharing her simple method for making a pattern on the well-known website Design-Sponge.com. Although there are numerous sites on digital pattern making easily found through any search engine, such as videos on YouTube.com, instructions by the fabric purveyor Spoonflower.com, or inspiration from the Dutch textile designer Zara Atelj's blog TheDailyPattern.net, there is nothing quite like the immediacy of putting pen or pencil to a sheet of paper. With the help of some folding, tape, scissors, and crafting, a one-of-a-kind pattern can be made and then replicated using a photocopy machine or some very simple Adobe Photoshop skills.

Here are instructions for a tile-able pattern based on Rothman's blog post and accompanied by a new set of instructional images.

MATERIALS

8 ½ x 11 inches (21.6 x 28 cm) paper

Black marker

Scissors

Tape

Coloring media of your choice, Adobe Illustrator or Photoshop, or scanner

STEPS

1. Start with a clean piece of 8 ½ x 11-inch (21.6 x 28 cm) paper.

2. Choose a black marker of the size that suits your design idea—fine tipped, medium tipped, or heavy tipped.

3. Draw an image in the middle of the paper, but do *not* let the image touch the sides of the paper [01].

4. Make the image as simple or as complex as you like.

5. When you finish the drawing in the middle of your sheet of paper, fold it in half vertically, unfold it, flatten it, and cut along the fold.

6. On a flat surface, swap the left half and right half, line up the blank edges, and tape neatly together on the back of the sheet. Make sure the edges of the sheet are lined up [02].

7. Now fold the sheet in half horizontally, unfold it, flatten it, and cut on the fold.

8. On a flat surface, swap the bottom half and top half, line up the blank edges and tape neatly together on the back of the sheet. Make sure the edges of the sheet are lined up.

9. Your design should appear at the edges of the sheet only. In the middle, the sheet is blank [03].

10. Now fill in the center of the sheet. Decide if you want to use the same size marker tip or change it. You can also decide if you want the center drawing to be simple or complex, whether you want it to be separate from the edge image or touching it. Remember, do *not* add any new marks to the edge of the paper!

11. Now you have a repeatable tile.

12. You can color the original, make color copies and apply them to a surface, or scan the line work and color it digitally in Adobe Illustrator or Photoshop. You can also tile the image digitally, making it as large as you wish [04].

01

02

03

04

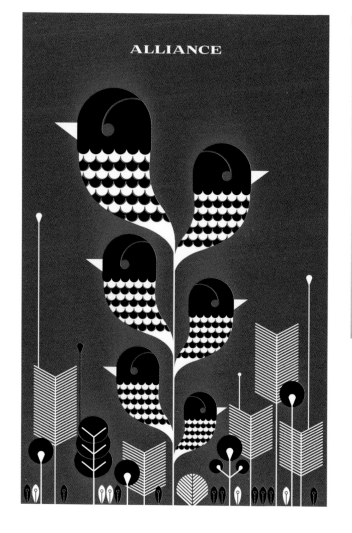

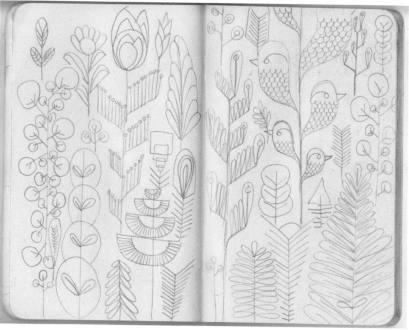

05

JUAN CARLOS VÁZQUEZ PADILLA

05 A sketchbook rough design and a final art example of how Mexican graphic designer Padilla uses patterns in his poster design and illustration work.

1 | BACK TO BASICS MATERIALS, SHAPES, AND PATTERNS

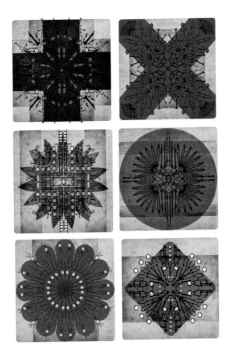

06

KRISSY DIGGS

06 Using hand-drawn letters, students in my HandLetters course at MICA created wallpaper patterns. Former MICA student Krissy Diggs used a limited selection from her weekly alphabet class exercises to construct patterned tiles in various colors.

MATT LYON

07 Not all patterns are repeatable—they just use similar shapes again and again. This pattern by Matt Lyon is dynamic because the action and direction of the tail-of-a-comet shape changes along with the object's scale, and Lyon uses eye-popping colors.

07

MARTIN HAAKE

08 German-born illustrator Martin Haake uses no less than four patterns in this piece, titled *Pipe*.

ZARA ATELJ

09 Dutch textile designer Zara Atelj uses imagery from the news stream and everyday life to concoct a variety of patterns that are visually beautiful and have meaningful content. Many go beyond a simple repeat to convey patterning as organic and unique as nature itself. Atelj combined her pattern experiments into an inkjet-printed publication called *The Daily Pattern*. "My natural sensitivity for materials, shapes, lines, curves, colors, and tones gives the design something unexpected. I'm mainly interested in projects dealing with interior textiles," says Atelj.

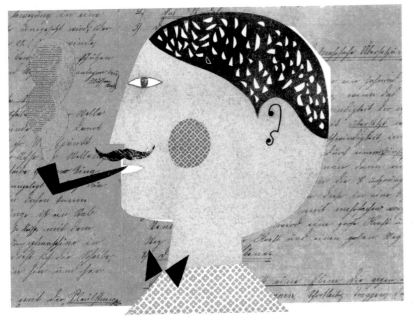

08

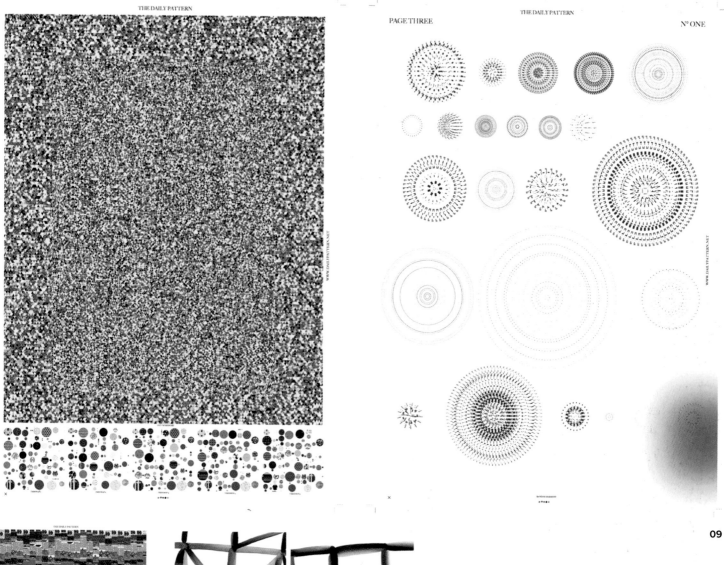

14. MAKE SOME MARKS

On her subway rides home,

Rachael Cole, art director at Schwartz & Wade, doodles in her sketchbook. It's her way of calming creative fears and getting ready to tackle bigger design puzzles—whether it's a book jacket design for a young adult novel or a personal project. Sometimes she draws representationally, sometimes when she's tired she just makes lines, dots, circles, or squares. Cole describes her process this way: "I try to do it according to a little system—like, make a circle with dots and don't stop until the next station." She also draws this way at home with Sumi ink on cover stock. Her biggest influences are Lynda Barry and Anton van Dalen, artists who believe in the power of mark making for "no reason." Cole's practice has been informed by both of them. Following is her recipe for making marks.

SUPPLIES

Large desk or table

Black Sumi ink

Small dishes for water and mixing Sumi ink

One ream 67 lb. cover stock, 8 ½ x 11 inches (21.6 x 27.9 cm), white or cream (for a less harsh feel)

Sumi brushes or large swabs*

Paper towels

Artist tape

STEPS

1. Start by mixing the ink with water to a consistency you like best. You can dilute your ink in several bowls to have a choice of light to dark grays to black.

2. Dip your drawing tool of choice in the ink and begin making random marks. Go as fast, or slow as you feel. You can later change what comes out visually.

3. Try different instruments to make different marks. Use light pressure or heavy pressure stamping them on to the paper to produce different results. You may need to experiment a bit to figure out how to make quick marks, or slow. Try loading your tool with a lot of ink, and then with just a bit ink. You get the idea!

4. Make stacks and stacks of images. No need to get precious; you have 250 pieces of paper to fill. At first you may want to just make dots, then try squiggles, arches and lines, or combos. Try packing the marks densely, then composing the page by making them far apart. Try making the marks as fast as you can. There is no wrong way to do this, just keep moving. The point is to work in a meditative way—a way of being mindful and in the zone. Try to fill at least 100 pieces of paper before you stop.

5. Wait for the entire surface to dry before stacking or scanning. Scan the most interesting pieces so that they're immediately accessible the next time you need some design inspiration. Cole keeps her scans in folders with descriptive names like "q-tip dots" or "beer can circles."

6. To start making imagery, copy and paste several favorite sheets into an Adobe Photoshop document on separate layers. To overlap the shapes, use the Multiply function and Colorize in Hue & Saturation. Click the Colorize button and use the slider bars to adjust your black-and-white patterns to color. Patterns can be rotated or scaled using the Transform tool.

* NOTE: The ob-gyn swab used to make Cole's drawings were "borrowed" from her doctor's office after he made her wait too long during an appointment.

RACHAEL COLE

01 Use this basic exercise to create varied shapes and sizes of marks. The more you make, the more opportunities for happy accidents to occur. Also, try making random and planned patterns with the marks.

02 When it came time to announce Cole's son's first birthday, she considered using type, but then realized she had a number of energetic marks just waiting to be used for something. She scanned in what she had and played with composition and color to get this lively visual.

02

01

TIP

Consider finding other marking tools to achieve your own unique marks, such as inexpensive brushes, toothbrushes, toothpicks, Q-tips, chopsticks, plastic spoons, beer cans, straws, or anything else!

15. BUNDLED TOOLS

This exercise is about bundling tools, either similar tools or different tools, to make drawings. The number of tools you can use at one time is limited, so pick them according to the weight or density of their mark or their color. Start first with your tool selection, then decide on the tool's angle best suited for you. Will you use the tools perpendicular to the paper surface? Or will you want to use your tools at an angle similar to normal writing? This decision will determine how you fasten the tools together. To achieve drawing perpendicular to the writing surface, hold the tools together with their tips touching the paper surface and either tape them together or bind them with an elastic band. To draw using your tools at an angle, hold them together at the most comfortable angle and choose one of the binding suggestions mentioned before. Using wet media increases the difficulty of this exercise.

In contrast with bundling traditional materials, working with digital tools gives a productive and visually distinct alternative. The bundled brush effect in Adobe Photoshop is a function of creating your own custom brushes using the dual-brush function which blends the properties of two separate brushes together. In your Brush Presets tab, choose any brush and then choose the Brush tab located to the right of the Brush Presets tab. In the Brush tab, click on the Dual Brush option. This will allow you to then choose a second brush to combine with your initial brush choice. Experiment by selecting any pair of brushes and trying the combination out. This process is all about experimentation and finding the effect you most like. The two brushes can be chosen from the preset brushes and combined, chosen from custom brushes you have made, or a combination of a preset and a custom brush.

SUGGESTIONS

- Consider making small jars of diluted inks, watercolor, or gouache to dip each brush in while still bound together.

- Practice using different pressures first before attempting a drawing.

- Use wet media first, allow it to dry, and then use the dry media tools on top.

01

02

SEO KIM

02 Bundled tool digital brushes example created by Kim. The top brush is the dual brush combination, the middle and bottom are the individual digital brushes selected.

03 Kim used the brush shown in image 02 to create this image of foliage.

01 Bundled tool marks in dry media of colored pencil.

03

16. FOUND OBJECTS

When one thinks of drawing, most often images of pencils, pens, and other tools for marking a two-dimensional surface come to mind, yet it is widely agreed that the term "drawing" has been understood differently at different times. One commonly accepted view on drawing is that it is a way of thinking about space. This exercise liberates you to subvert any academic models you have learned and open your mind to what the act of drawing can encompass, such as drawing with found materials. Designer and illustrator Melinda Beck has made a career of being inventive with her image making. "I have always been open to experimenting and trying things I have never done before," she notes. She makes most of her creative decisions during the sketching process, where she can put down any idea that comes to mind, "even the really dumb ones." Once she has a sketch she likes she can easily see what the completed piece will look like. "Then I try to recreate this idea in reality," she says.[1] Beck is a fan of collecting what she calls "useless, but pretty objects." Her collections of common and unusual objects have inspired and driven forays into experimenting with materials to create images and letterforms.

01

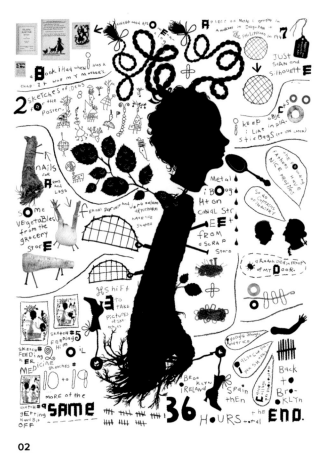

02

[1] Jessica Goldfond, "The Little Interview with Melinda Beck," http://shinysquirrel.typepad.com/shiny_squirrel_/2009/05/the-little-interview-with-melinda-beck.html, May 2009.

[2] Will Sherwood, http://willsherwood.com/interviews/interview-with-

MELINDA BECK

01 A finished poster for an exhibition at Spur Gallery in Baltimore. This piece uses wire, string, washers, tape, and gears. Can you find them all?

02 *Just Another Day on My Desk*, seen on the cover of this book, is a veritable instruction book for how Melinda Beck makes imagery from found objects, including vegetables, string, nuts, wire, paper tags, nails, tape, washers, and paper.

03 In an impromptu response to her materials, Beck created this remake of the well-known symbol for the Republican Party, formerly call the Grand Old Party, or GOP.

03

Designer Carin Goldberg is equally gifted at demonstrating the range that objects have in creating imagery. Like others who entered the professional realm in the 1970s, she was able to expand her understanding of imagery through a combination of academic art and commercial design. Her earliest exposure to drawing in design was at CBS television with Lou Dorfsman. "On my first day, Lou handed me a yellow ledger pad filled with sketches (drawn in red pen) for logos for the newly established Museum of Broadcasting. He stuck me in the corner of an empty workspace and told me to 'work them up.'"[2] This mandate quickened her drawing skills, skills that appear to have stayed with her throughout her design career. Her recent personal poster work, titled *Paris* and *Reinvention*, demonstrates a keen eye for drawing with objects.

CARIN GOLDBERG

04 *Reinvention*, Carin Goldberg uses paper merchandise tags with strings to reinterpret nineteenth-century silhouetted portraits. Her inclusion of words on the tags to suggest a narrative adds depth to the viewer's experience.

05 *Paris*, Goldberg captures a very personal experience of the City of Lights in this poster, created for AGI/Paris. Using found labels and an old engraving of the Eiffel Tower, she evokes the endearing nostalgia of Paris and simultaneously draws a natural hierarchy. Her choice to use a manual typewriter on the labels, as opposed to hand-drawn words, clearly sets the timeline she wants this piece to evoke.

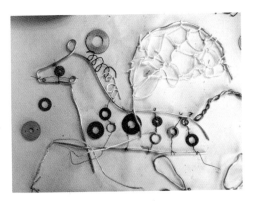

06

07

MELINDA BECK

06 A work-in-progress, 100th anniversary cover for *Poetry Magazine*, shown before it is digitally silhouetted, demonstrates the variety of line work that emerges from drawing with found objects.

07 Beck created letterforms from string. She has to be careful not to use too much glue when attaching it to the board.

BO LUNDBERG

08 Bo Lundberg originally created this image for an agency promotion where he was asked to illustrate his favorite book. He chose the Pantone book. This piece not only uses the principles of found objects but also conceptually examines the client's directive in a nonlinear way.

CRISTINA GUITIAN

09 Spanish artist Cristina Guitian was commissioned to create a poster for the Brazilian workshop, Brainstorm Shop, covering brainstorming and design thinking processes. Denis Kakazu & Marcelo Pena Costa, founders and creative directors, chose Guitian for her still life sculptural work and gave her complete freedom to come up with a visual interpretation of the workshop's title. Guitian put together a group of tactile objects to represent the multitude of ideas generated in the brainstorming process. Look closely to discover the objects that compose the workshop title. They are not visible at first glance, but camouflaged in the group of objects. The artwork was awarded with a Slice D&AD Award and included in their 2012 Annual.

SUSAN FARRINGTON

10 Susan Farrington's *20 Faces*, done for California design studio Warren Group/Studio Deluxe, is expressive and eclectic. Using numerous found materials such as paper, cloth, metal, fur, string, and vintage office supplies, Farrington takes advantage of each piece of material to "draw" personality and expression into the faces.

11 Many found-object image makers collect interesting odds and ends such as ribbons and vintage ephemera on a regular basis, storing them in marked boxes. Notice the way illustrator Susan Farrington brilliantly modified strips of vintage binding to make the arms of this figure. The miniature pieces used to make the face are attached with tiny spots of glue.

08

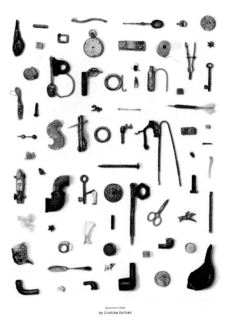

09

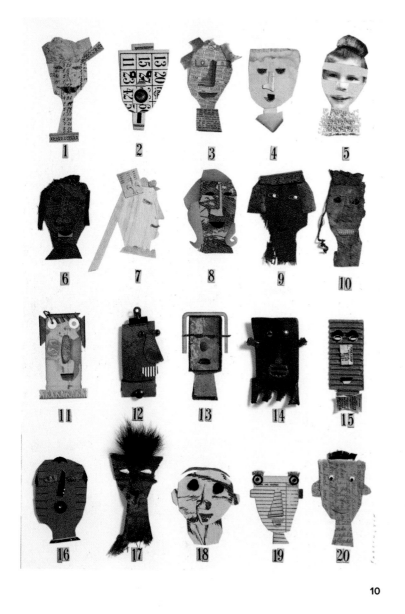

10

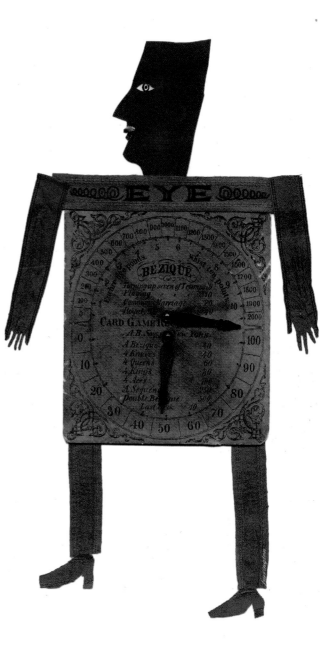

11

TIP

By keeping an open mind about what it means to "draw," working with found or unconventional objects empowers you to take bold steps in image making.

17. NONDOMINANT HAND

Drawing with your nondominant hand can seem like a difficult, even foolish endeavor, except if you are seeking a new line or form. Many years ago, the majority of my drawing was done with photographic reference, yet I yearned to create exaggerated and playful shapes. Relying on my memory of forms, I challenged my unskilled "other" hand to recall those shapes. The goal was not to get better at drawing with my nondominant hand, though in short order I could see improvements. The goal was to see my accidents, memorize them, and recall them later as I ventured to change my mark making and the overall look of my work. Your drawing muscle memory becomes accustomed to making certain marks and perspectives that may make your drawing stale or uninspired. By using your nondominant hand, you will discover a new language for your line and form. According to Dr. Betty Edwards, author of *The New Drawing on the Right Side of the Brain*, by attempting to draw wrong-handed the drawer creates a "set of conditions that create a left brain vs. right brain struggle."[1]

Here are some guidelines for working with your nondominant hand:

1 Use a tool that you feel comfortable with.

2 Find the surface angle that is right for you—seated using an angled surface such as a drafting table, or standing with paper flat on a table or pinned to the wall.

3 Visualize the shape in your mind before making the mark.

4 Do not judge the marks. Remember, you are looking for new marks.

5 Do several sheets, making the marks independent of each other as well as overlapping.

[1] *Betty Edwards,* The New Drawing on the Right Side of the Brain *(New York: HarperCollins Publishers, 2001).*

HOUSE OF ILLUSTRATION STUDENTS

01 House of Illustration is "the world's first dedicated home for the world's most accessible art form." They champion illustration by exploring its riches and celebrating the way it touches our daily lives through advertising, animation, picture books, political cartoons, medical drawing, fashion, and much more. House of Illustration also has a mission to provide education on the practice, creating awareness of illustration's power to communicate. The House of Illustration's program, Picture It: Inspiration through Illustration, champions creative approaches to literacy by bringing together professional illustrators, students, and teachers to work on practical illustration projects. They feel that illustration is an ideal medium for developing communication, reading, and writing skills. These are examples of one Picture It project. The drawings were produced as part of workshops delivered by House of Illustration, where the students created a drawing with their dominant hand, then one with their nondominant hand.[2]

18. CHARACTER SILHOUETTES

Many of the drawing exercises

In this book are devised to produce habits and skills that will help you be a better drawer and thinker, yet some of the outcomes may not be initially apparent. However, the goals of this exercise *are* apparent. Sketching character shapes is not just fun, but is also a direct path to discovering whether the character you have drawn is visually active, is identifiable, and effectively communicates the unique qualities of that character. You will find this kind of exercise and thinking is exceedingly helpful when you need to design a successful pictorial logo.

I've used this exercise over the years to show illustration students how an effective silhouette on objects makes a better drawing when it is fully rendered. They received the steps of this exercise one at a time, without knowing where the exercise was going. Draw a character, photocopy it, and fill it in.

I asked award-winning designer and illustrator Chip Wass to demonstrate this exercise in his own way. Wass is known for creating exuberant characters for clients such as Disney, Nick Jr., and the Cartoon Network, along with many editorial and publishing projects. Here, he breaks down the process.

01

02

03

04

CHIP WASS

01 Wass starts with loose, rough pencil sketches in the beginning. "Try not to edit your shapes or mistakes too much. Just scribble. I usually use simple flat shapes in my drawings, but staying loose helps keep the final digital piece (if made) from feeling too cold," he explains.

02 Next, he makes a photocopy of the sketch, or covers the drawing with a sheet of vellum or tissue, then fills in the drawing. Wass says, "See what it looks like. Good character imagery should be a quick read. If it's clear what the character is doing in silhouette, it will pop. Taking the character to silhouette reveals elements that feel mushy or unclear." To refine the shape, go back to the pre-silhouette drawing and rework it, eliminating the less effective details. Repeat the "filling-in" process until the best character figure emerges.

03 Wass uses flat graphic line work and color to make his characters pop. He recommends doing a quick sketch in Adobe Illustrator with templates. "It's a sort of midpoint between freehand and the computer," he says. You can also scan the art and digitally draw on a layer on top. Do this a few times to find the right balance.

04 Wass draws his final image directly on top of the pencil sketch. "Letting the computer's gadgetry simplify and organize the image will produce a super clean final," he explains. You will also have a more animated character shape for your next pictorial logo project.

LISK FENG

05 MICA MFA in Illustration Practice student Lisk Feng loves characters. She regularly fills her sketchbooks with them. She is also a published book illustrator in China. Feng was asked to try the Character Silhouettes exercise to see which of her characters naturally has a visually interesting or active shape or silhouette. She started with her existing sketches. Using tracing paper and a brush-tipped marker, she quickly filled in the shapes below. If preferred, vellum or standard-tip markers or pencil also works well. It's up to you to decide your usual favorite tool, or it can be a great time to try something new!

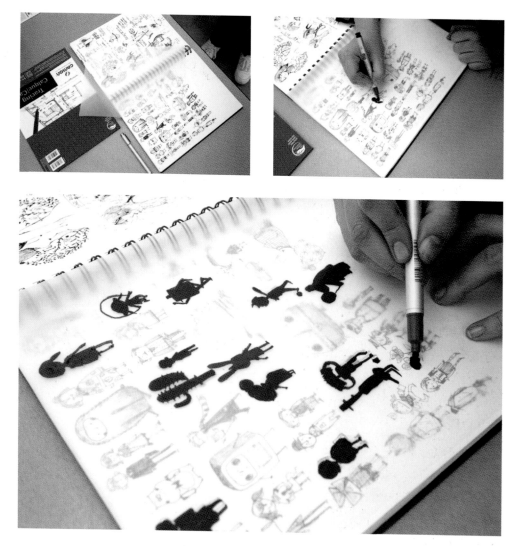

05

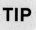

TIP *Consider creating several alternate poses of the character before filling in to examine the profile.*

TIP *If you like the look of your silhouettes, consider researching paper cutting or German Scherenschnitte, literally translated as "scissor cuts."*

06

07

RICH SPARKS

06 Long fascinated with silhouettes, illustrator Rich Sparks turns this exercise on its head. By filling in the background he can achieve a similar profile effect, but he also integrates elements previously covered in the Dry Brush and Collage exercises in this book. "To me, silhouettes are mysterious and revealing at the same time," he says. "The good ones focus the eye on the essential components of a figure while requiring the imagination to do the actual seeing."

BO LUNDBERG

07 Swedish illustrator and designer Bo Lundberg shows how well-designed exterior shapes effectively convey specific messages without interior details. Each element has style and character for this South African wine promotional art. Lundberg's elegant shapes are enhanced by his selective use of color.

BOMBOLAND

08 *Wired* is an editorial created by Bomboland, a studio located in Lucca, Italy, for *Wired* magazine UK. The illustration was for an article called "How to Start Your Own Country." This piece combines elements of character and silhouette in a 3-D format.

08

19. IMAGE HARVESTING

In the book *The Surrealist Mind* by John Herbert Matthews, the author warns that true Surrealists were wary of what he calls "self-kleptomania," or exploiting their past discoveries and giving up risk-taking. The style-resistant Surrealists preferred to abandon a technique or method if it was mastered for fear of losing their creativity. Readers of this book should not fear stealing their *own* past discoveries, because harvesting the seeds of ideas is much like harvesting seeds from your vegetable or flower garden. Each new "planting" yields a new crop, related to the previous idea, yet unique.

01/b

01/a

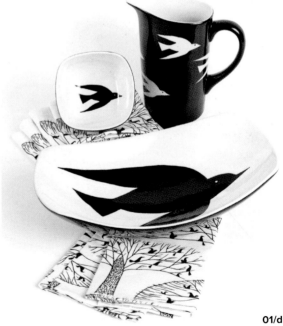

01/c

01/d

WHITNEY SHERMAN

01 The idea of image harvesting is to look back on previous work to discover key aspects or parts of images that can be regrown into new imagery that can be developed further. The *BlackBird* series was distilled from a commissioned drawing that I liked. The drawing appealed to me so much that I decided to harvest it and produce a set of painted ceramics [a]. I liked the results so much that I decided to translate the harvest into a pattern to produce a set of tea towels and appliqué for pillowcases [b]. The third variation was then a graphite-style drawing on a vase [c]. The latest variation removed the detail of the original harvest, making a more graphic interpretation of the image [d].

GUIDO SCARABOTTOLO

02 This laser-cut shape called *Angel* [a], made for an exhibition of different figures titled *Iron Drawings*, started as a vector file. Guido Scarabottolo then went on to use some of the large iron plates to create monotype prints [b] that incorporated rust from the plates into the ink impression. For the third image, Scarabottolo went back to the vector file to create this mixed-media exhibit poster, *The Angel of the Far Away* [c], for Tapirulan, a cultural nonprofit in Cremona, Italy. These three pieces show how engaging and versatile the shape of the angel is for Scarabottolo.

MARTIN HAAKE

03 Martin Haake's piece for the German publication *Rotary* magazine utilizes both collaged and décollaged shapes of the soldier at the right holding a bayonet. By harvesting this element, he has effectively created the front flank of foot soldiers. He recognizes the value of harvesting this one element, then translating it in different ways to his advantage. Using collage and décollage in this way, Haake creates compositional depth, visual interest, and texture in his work.

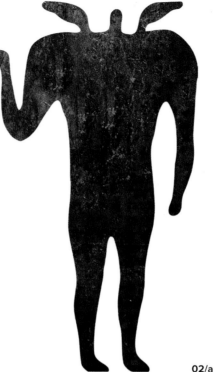

02/a

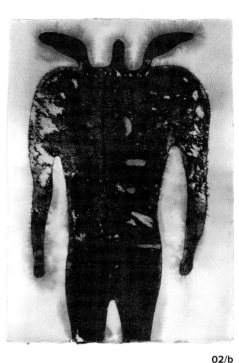

02/b

02/c

03

20. DRAW ON YOUR WALK HOME

Designer and educator Mark Sanders encourages his students to try this exercise in each of his classes. The goal is to make detailed observations from your walk home or from your current surroundings, and then elaborate on it in a drawing. From this experience, a single shape is repeated to form patterns or abstractions.

To begin, reduce an object, a gesture, or a detail you've observed into lines or shapes that can be repeated. Once you've determined a module, rotate it, mirror it, alter its size, and so on to create variety and interest. For geometric patterns, draw on graph paper. Organic patterns can be achieved with a blank sheet.

The starting point for Sanders's exercise may be a thought or a found form, but once it is determined, the drawer should stop thinking and get lost in the act of making marks intuitively.

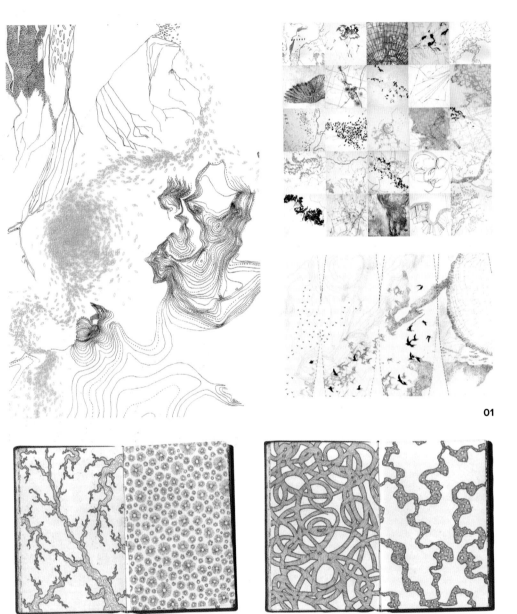

01

02

MIMI ROJANASAKUL

01 Mimi Rojanasakul, a graduate of the Pratt Communication Design MFA program, is driven by concept, as is evident in these drawings she calls *Subjective Cartography*. She says of her drawings, "Symbols for topographies and graphs are stripped down to reveal archetypal structures that connect man-made systems back to nature."

TANYA HEIDRICH

02 Tanya Heidrich is an undergraduate design major at MICA. She describes her textural doodles this way: "My starting points vary, but often they do emerge from objects in my surroundings. They are also often variations of similar shapes/patterns/relationships that I've used in the past."

WHITNEY SHERMAN

03 As an assignment for the *New York Times*, the author was asked by then-art director Leanne Shapton to observe a water fountain at a specified hour of the day. Sherman says, "I was to draw the fountain and make observations about the drinkers at the fountain—what they acted like, what they wore, and so on. These sketches were of a fountain I passed on my regular walk. Unfortunately, no one came to the fountain while I was there, but I did make three completely different drawing approaches in less than the hour I sat observing, including one with real grass collaged on to it. I did a second set observing a water fountain in a mall. There was much more activity, but the fountain was not as attractive as this one."

JORGE COLOMBO

04 In a less formal setting than the classroom, the Portuguese illustrator has used his walks home as a way to keep his eyes open to his surroundings. Colombo says his iPhone drawings *Katz's* [a] and *Empire Diner* [b], used as covers for *The New Yorker*, "represent me having fun with the brightest, fastest, lightest, cleanest paintbox/sketchpad I ever played with. You lose the tactile aspect, but you can work in the dark and don't have brushes to wash," he explains. He notes that Katz's was only his second touch-screen drawing.

03

04/a

04/b

21. **COLLABORATIVE PATTERNING**

Collaborative patterning is a variation of the patterning exercise. This communal effort produces interesting and unexpected results and is most compelling when done with a group of strangers. Seeing your work not just in proximity, but somehow integrated is refreshing. To create a group, invite three friends and ask them each to bring three other friends. Plan your gathering in a studio or an office that has a simple copier, or if one is not available, then use a scanner and printer.

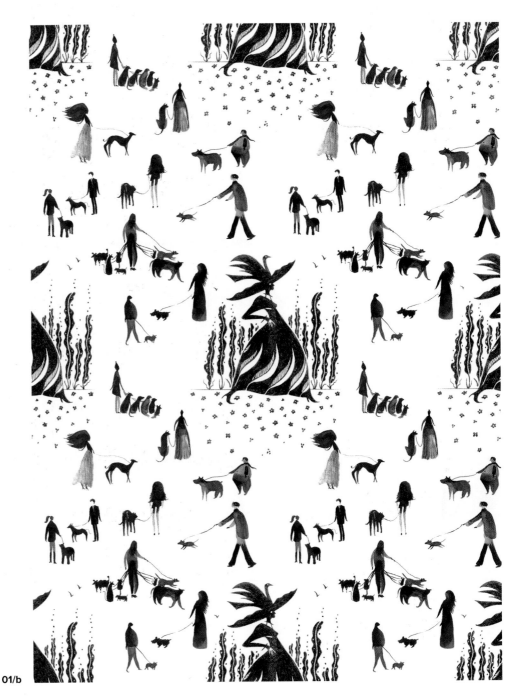

01/b

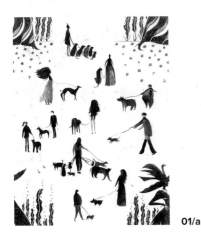

01/a

WHITNEY SHERMAN & SARAH JACOBY

01 Start with a sheet of 8 ½ x 11-inch (21.6 x 28 cm) paper or other standard size, and have participants follow the directions in the How to Make a Pattern exercise in Chapter One. Follow the instructions to reassemble the image and tape it together, and then pass your drawing to another in the group. Once everyone has a new drawing [a], complete the pattern. The examples shown here were made by the author and MICA MFA in Illustration Practice student Sarah Jacoby. To see how amazing these patterns are, photocopy or scan and print the new image into nine sheets and tape the multiples together [b]. The more copies you make, the larger the wallpaper pattern. If you really like a pattern, consider making a high-resolution file to print out as digital fabric, print as a screen print, or transfer to a linoleum block to make a linocut.

01/a

01/b

22. CUBOMANIA

Romanian poet and Surrealist theorist Ghérasim Luca (1913–1994) is credited as the originator of the Surrealist game Cubomania. The Surrealists, a movement founded between World War I and World War II whose major spokesperson was the poet and critic André Breton, produced "anti-art"—art that went against the social rationalism of European culture and politics. Despite this attitude, Surrealism was decidedly a positive movement in contrast to its predecessor, Dadaism. Surrealists wished to unite and express both the conscious and the subconscious mind through the power of imagination. This exercise will have you create a drawing, cut it into precise squares, and rearrange the squares to break free of pictorial logic. To replicate the original game instructions, you will need to follow these steps.

MATERIALS

Paper

Drawing media of choice

Ruler

Scissors

STEPS

1 Draw a picture. Using color in your drawing will show the effects of this game best. If you only use one color, vary the line weights.

2 Give the drawing a certain level of complexity. If it's too simple, the game doesn't work as well.

3 Carefully measure out and draw a grid on the front or back of the drawing. Consider the imagery, scale, and proportion of the paper before you decide whether to use 1-inch (2.5 cm) squares or squares that are larger or smaller.

4 Cut up the squares. Mix them up and rearrange them into a new image. Try not to plan this, but allow accidents to happen.

Like many Surrealist games, this exercise can be playfully adapted. Alternatively, use two or more separate images, swapping the pieces into a new arrangement.

Another adaptation involves going into the third dimension. MICA MFA in Illustration Practice student Tong Su became interested in what her illustrations could do in three dimensions. She was also interested in fashion, so when she participated in a paper engineering workshop, she saw some possibilities for testing out a few of her theories.

TONG SU

01 Using one of her landscape drawings, Su digitally printed her image onto a lightweight fabric that is laminated on paper.

02 Su carefully cut her image into uniform squares.

03 The size Su chose was purposeful to the final construction she planned. The pieces shown are 1-inch (2.5 cm) square.

04 Su then made basic origami folds in her pieces, forming a four-pointed star shape. She purposefully folded each piece to have the drawing end up on the inside of the form and randomly mixed up.

05 Using spots of white glue, Su then attached the individual forms point to point. The form that emerged is flexible and has the effect of the remixed drawing.

01

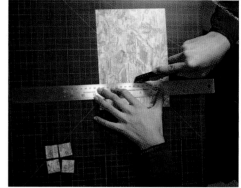

02

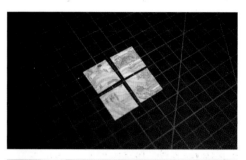

03

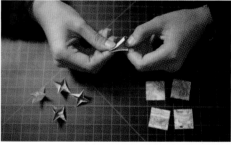

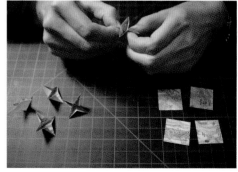

04

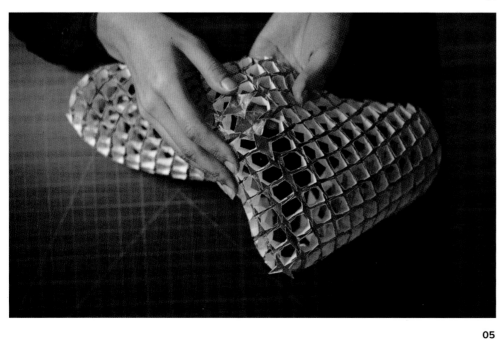

05

23. MÖBIUS STRIP DRAWING

A Möbius strip or band (also spelled Moebius), named after the nineteenth-century German mathematician and astronomer August Ferdinand Möbius, is a nonoriented single-sided surface with only one boundary. This continuous surface makes it an interesting surface on which to draw. Maurits Cornelis (M. C.) Escher rendered this form in his well-known 1961 and 1963 woodcuts *Moebius Strip I* and *Moebius Strip II*, and alludes to the form in his 1946 block print *Horseman* and other illusionistic works, like his 1953 lithograph *Relativity*. All of these can be seen on his official website. What makes drawing on this shape so interesting is the potential to create a series of images that defy the usual two-dimensional surfaces. The continuous surface allows us to think of one thing morphing into another on a magically shaped object. It also brings two-dimensional work visually into the third dimension.

MATERIALS

Medium-weight paper

Scissors

Ruler

Drawing media of choice

White artist's tape or matte clear tape

STEPS

1 Plan out an idea for a set of images for each side. They can be related or unrelated. If you decide on unrelated images, increase the left and right margins in step 3.

2 Using a medium-weight paper, cut it into 2-inch (5 cm)-wide strips at least 16 inches (40.6 cm) long. Make sure you keep the width consistent from one end to the other. This will ensure you can easily assemble the strip when you're finished drawing.

3 Begin your drawing about ½ to 1 inch (1.3 to 2.5 cm) from the left edge and continue drawing until you get to the same distance from the right edge. Use any drawing tool you wish, but pen and pencils are the best for small-scale drawings.

4 Finish side one, and then turn over to start side two. Be sure to flip the paper vertically (turning the top to where the bottom was) so that the bottom of the first drawing matches the bottom of the second drawing. Remember to leave space at the left and right ends.

5 When finished drawing both sides, take both strip ends and, pointing them toward each other, give one end a 180-degree twist and tape the edges together. White artist's tape or matte clear tape is best. Take your time to make sure the joining is even.

6 Using the same drawing tool, connect the drawings together. If you drew different things on each side, this will be your challenge—to join the different drawings together.

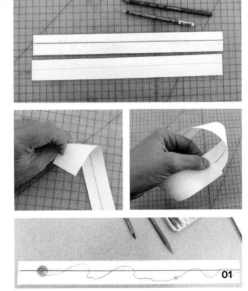

01

02

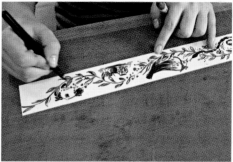
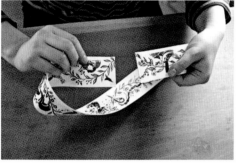
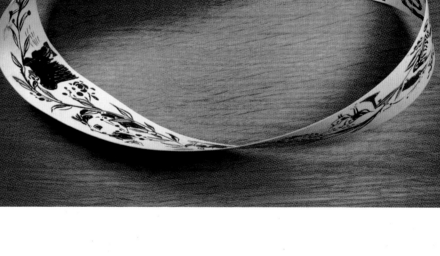

SARAH JACOBY

01 First-time Möbius strip builders may want to start simple. To orient your drawing and practice making a Möbius strip, draw a different colored line on each side of the paper. Twist 180 degrees and join to see how the two paper surfaces become one.

02 A finished Möbius strip of cats chasing a ball of string is completed by MICA graduate student Sarah Jacoby. This example demonstrates construction using a shorter length of paper. The length of the paper has a significant effect on the final shape of the assembled Möbius strip.

LISK FENG

03 Following the directions for making a Möbius strip, MICA MFA in Illustration Practice student Lisk Feng decided on a two-color pattern of characters and foliage.

03

TIP *Plan out drawings that will be sequential, changing size or moving through time so that the assembled strip creates a continuous progression. Or try your hand at joining random imagery.*

24. **DRAW A PROCESS**

Expressing a process step by step is an important part of our lives. Learning how to fix a car or cook a meal, and the proper way to leave a building in case of fire, are all vitally important processes to know. Drawing a process requires that enough information be given to explain things well, yet not so much that the viewer loses interest in the instructions or gets confused. Explaining a process visually rather than with words overcomes any language barriers. This is why Ikea uses graphical instructions, including the number of screws and pegs you will need (but sometimes won't get) in your package. Yet for this sort of graphical drawing to work, it has to be communicative. To take it to another level of visual sophistication requires a point of view. The examples shown here run from the essential to the escapist. I've also included drawings of processes that are less than predictable. Let's start with the essential.

01/a

01/b

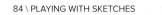

02

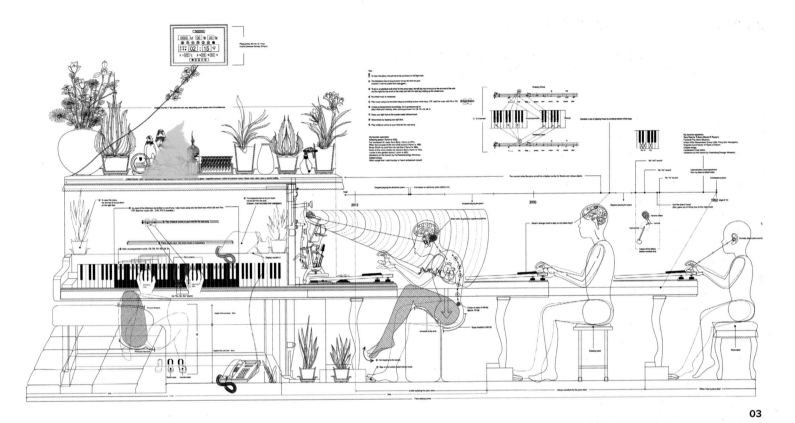

03

VALERIA MOLINARI

01 Valeria Molinari's *How to Cut an Onion* [a] is a clear set of instructions that, no matter which language you speak, you can understand very clearly. Molinari creates a hierarchy in the composition, starting with the most important things at the top left and moving across and down to the last step. Just as with *How to Cut an Onion*, the image *How to Iron a Shirt* [b] is easily read because of the clarity of images and the sequence and layout used. *How to Cut an Onion* systematically uses the page layout to give the instructions organization, where as *How to Iron a Shirt* relies on numerals to help the viewer grasp the instructional system.

02 Molinari's sketchbook images *Preparing for a Flight 1–3* are not planned "process" images, yet they tell a story of what it is like to go on an international flight, conveying the flurry of activity, packed environments, and abundance of instructions thrown your way by the flight staff. Using a completely different methodology for showing a process, she includes a technical checklist for preparing for a flight, instructions passengers are supposed to follow before takeoff, ticket checks, emergency exits, last-minute check of a cell phone, and so on. The layout of the page is informal and allows the viewer's eye to skip freely from place to place, replicating the visual overload we sometimes feel. Though *Preparing for Flight 1–3* is less predictable visual reading than *How to Cut an Onion*, the process of waiting for a flight to take off can bring a similar number of tears.

MINJEONG AN

03 Korean artist Minjeong An uses the language of diagrams to represent complex ideas. Here she represents the process of piano playing, but she integrates the process into a domestic scene, bringing personal interpretation and meaning to the work. The image also contrasts the domestic scene with the scientific nature of diagrams.

○	# in circle indicates # of chains for loop
◯	chain
•	slip stitch
+	single crochet
T	half double crochet
†	double crochet
‡	treble crochet
‡	double treble
⋇	sc3tog
⊖	dc4tog
⊕	dc-cl
⋇	dc5tog
⊥	base stitch

05/a

05/b

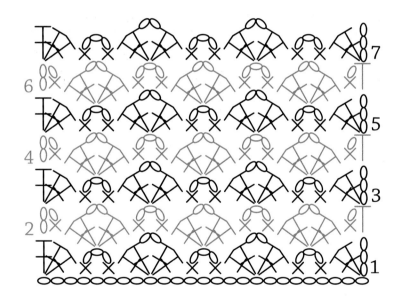

how to make a perfect, spicy & simple
bloody mary:

1 start with a large full sized glass- we're not messing around here...

2 fill it almost to the top with ice (**not** crushed)

3 add at least a 1/2 teaspoon of plain ol' horseradish.

4 squeeze a lemon wedge in there if you're lucky enough to have some on hand.

5 then, about 4-5 glug-glug-glugs of worcestershire sauce. I caution you not to miss this step!

6 Sprinkle some creole seasoning for a good measure, but not too much because it could get too salty.

7 crucial moment! you'll need at least 3 hearty shakes of your favorite hot sauce. tabasco is always a solid & trustworthy choice.

8 booze it up!! fill it about half way, unless you are trying to stay sober. don't use expensive vodka, it's not necessary.

9 now, fill the rest up with bloody mary mix (preferably a bold & spicy variety, but if you don't have any, you'll survive— I think)

10 stir it up! you could be done... but I recommend any or all of the following:

cayenne pepper

celery salt

fresh celery

green olives

always top with fresh ground pepper!

ROBYN CHACHULA

05 Crochet diagrams are both visually interesting and instructional. To the untrained eye, they appear to show what the final crocheted pattern will look like, but to the experienced eye, technical instructions are embedded in the marks of the diagram. To decode the instructions, the reader must look at the key [a]. I chose this example of drawing a process to show that diagrams many times exceed their basic purpose and through their own unique language can be an inspired way to think about drawing. These motifs [b] are from *Blueprints Crochet* by Robyn Chachula, text ©2008 Robyn Chachula, illustrations ©2008 Interweave Press.

JEANSOO CHANG

06 Jeansoo Chang drew *How to Fillet [sic] Fish* as part of a course titled Illustrating the Edible at MICA. The students were instructed to create a step-by-step set of visual instructions that would make a new process clear to the reader. Chang's piece employs a high level of visual organization with elements of commentary.

KELLY LASSERRE

07 Kelly Lasserre's *How to Make a Perfect, Spicy & Simple Bloody Mary* uses a good amount of hand lettering as an integral part of the image, adding texture and giving plenty of visual reference to bottle labels. Lasserre gives the viewer an ingredients list, as well as interesting product visuals that are key elements within the handwritten instructions.

25. DIAGRAM AN OBJECT

One of my first encounters, and loves, of diagrams was in fourth grade, when I learned to diagram a sentence. I thought the simple lines each word sat on and the rules that determined the placement of one word to another was elegant and mysterious—so much more visual than being assembled in a straight line. My next diagram love encounter was an exploded diagram of a car engine. This technical drawing style shows the parts of the engine, mostly things you can't see without taking the engine apart, arranged in their order and relationship to each other. The precision of the drawing and the stopped motion dynamics were complex, yet the drawing made me feel like I understood the engine in a new way. Leonardo da Vinci had already mastered this form with mechanical and organic objects. The difference between the fifteenth century and the twentieth century is the interest in and ability to create mechanically precise shapes. Nothing amplified that point more than the advent of vector art. Drawing the parts of an object can be as complex as an exploded engine diagram or as simple as an eight-bit diagram of sushi. Whichever direction you choose, it's the idea, not just the style, that makes the drawing interesting.

Here are some suggestions:

1 Observe an inanimate object and draw what you imagine is inside of it.

2 Disassemble two different things, recombine them in a new and interesting way, and draw.

3 Diagram a text message or an email. Seek help with a how-to if you are not acquainted with the rules of sentence diagramming from *Sister Bernadette's Barking Dog: The Quirky History and Lost Art of Diagramming Sentences* by Kitty Burns Florey (Random House, 2006).

4 Trace a profile of your head and draw the parts of your brain, real or imagined.

5 Using a favorite paragraph, draw a pictogram to represent each sentence and arrange them in the order they were written. Make the size of the pictogram appropriate to the importance of the sentence in the paragraph or based on dramatic effect.

6 Draw the major moments of your life as if it were a layer cake.

7 Using László Moholy-Nagy's 1946 diagram of *Finnegan's Wake* as a model, diagram the parts of your favorite book.

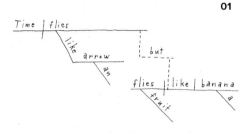

01

01 Kitty Burns Florey, author of *Sister Bernadette's Barking Dog: The Quirky History and Lost Art of Diagramming Sentences*, also writes for the online column Opinionator for the *New York Times*. She is an advocate of sentence diagrams, seeing the process as one where sentences turn into pictures.[1] In the June 18, 2012, column titled "Taming Sentences," Florey noted how diagramming sentences "illuminates points of grammar." She noted that when diagramming, "we focus on the structures and patterns of language." Yet beyond the structures and patterns, she recognizes that diagramming is basically a puzzle, and that puzzles keep our brains working. It can produce a kind of visual poetry. In fact, the originator of sentence diagramming, schoolteacher Stephen Watkins Clark, noted in the preface of his book on the subject that "making the abstract rules of language into pictures was like using maps in a geography book or graphs in geometry."[2]

JUDE BUFFUM

02 The Japanese automobile company SCION sponsored a curated show at Giant Robot in Los Angeles, California, titled Pixel Pushers. Philadelphia designer and illustrator Jude Buffum was invited to participate, so he decided to examine the carnivorous side of the world of video games. His longtime obsession with butcher diagrams and fascination with 8-bit video games were the inspiration for this series.

02

04/a

04/b

03

MARTIN HAAKE

03 Martin Haake's illustration uses diagrammatical elements to convey the message in this advertisement, originally commissioned by J. Walter Thompson, rather than literally diagramming the text. Much like a pictograph of a rotary dial phone is visually more interesting than one of a cell phone, these mechanical elements get the idea across in a more engaging way with basic working shapes like screws, springs, and levers.

MICHAEL PAULUS

04 Michael Paulus's curiosity made him wonder what a skeletal system of a creature with eye sockets half the size of its head, or fingerless hands, or feet comprising 60 percent of its body mass would look like. He notes, "These characters have become conventions that are set, defined, and well-known personas in our culture. Being that they are so commonplace and accepted as existing I thought I would dissect them like science does to all living objects—trying to come to an understanding as to their origins and true physiological makeup." Shown here are Betty Boop [a], an American animated cartoon created by Max Fleischer first seen in 1939, and Charlie Brown [b], the well-known main character from Charles Schulz's syndicated comic strip of the same name.

¹ Kitty Burns Florey, "A Picture of Language," Opinionator, New York Times, March 26, 2012.

² Kitty Burns Florey, "Taming Sentences," Opinionator, New York

05

06

MINJEONG AN

05 About ten year ago while working as a web designer, Minjeong An came across an architectural floor plan on the web. She found the complicated lines and signs beautiful and compelling. At that moment, she saw the beauty of the drawing's dots, lines, and labeling as neither decorative nor auxiliary, but important carriers of information. "I think the impression of the blueprint was quite deep," An says. "When I was in graduate school, one day I thought of measuring myself with rulers and creating a self-portrait." An wants to convey things like personality, energy, aura, and even past memories, making the invisible visible. To draw people into everyday things, she uses an authoritative appearance of scientific schematics. In her self-portrait, An also wants to juxtapose the cerebral with what she calls "gentle sentiments" to balance the viewer's experience.

D. W. KELLOGG

06 *A Map of the Open Country of a Woman's Heart* by D. W. Kellogg was created circa 1833–1842 and chronicles social perspectives of womankind in the nineteenth century. The map's subtitle, *Exhibiting its internal communications*, and the facilities and dangers to Travellers therein, gives a picture of who is making the observations (a man) and how much trepidation he has entering the realm (much). Through a series of text labels and the overall charming shape of the map, Kellogg conveys more about himself than of any particular woman. Many maps of imaginative places proceeded this one, and the tradition has continued to the present day, including one by cartoonist Jules Feiffer for *The Phantom Tollbooth* and a map titled *Isle of Knowledge* by designer Marian Bantjes for *Varoom*, the UK illustration magazine, for their issue on knowledge. Discover more on this through web research, or start with Maria Popova's weekly online digest, *Brain Pickings*. Look for her entry titled "Mapping the Human Condition."

WARD SHELLEY

07 Ward Shelley's delightful *History of Science Fiction* is as visually mnemonic as it is informative. Inspired by H. G Wells's *War of the Worlds*, Shelley created a copious diagram that maps the whole literary genre of science fiction as a tentacled beast. The organic shape helps fuse the varying aspects of sci-fi history into one, including wormholes and ganglion-like forms, and allows the viewer to move fluidly around the shape. Shelley's diminutive hand lettering gives a sense of scale to the history that is diagrammed, and his use of color suggests brain matter, bile, and blood.

07

26. FIVE-MINUTE DRAWINGS

What can you accomplish in five minutes? In the time it will take you to read this introduction, you could begin this fun challenge and recruit others in this scheme. That's what Idiots'Books partners Matthew Swanson and Robbi Behr do to fill small pieces of open time or to kick-start their day. Swanson and Behr are no slouches when it comes to time. They have three children, manage writing and design commissions, and run their own indie publishing house. Their business alone requires constant planning to write, design, and illustrate their books, post to their blog, and participate in book festivals like MoCCA and SPX. All mixed together, they are very busy folks, but they make sure they find the time to draw. Here are three ways Swanson and Behr make drawing fast work for them.

IDIOTS'BOOKS

01 Behr and Swanson share the same space (living and working), yet some days this gives them less time than usual to interact in fun ways. To make up for that, they pick a topic (happiness, doorknobs, Sean Connery) and then start a timer and see what they are able to come up with in the span of five minutes. They even recruit their intern, Tilly, to join in the fun! Here they tackle the word lotion, each using different tools, including an iPad and markers. Left to right, Robbi Behr, Matthew Swanson, and Tilly Pelczar.

02 Being as busy as she is, Behr sometimes finds herself awake in the wee hours. She smartly used that time to draw on her iPad with the application Procreate to make the images *Betrayal* [a] and *Iceberg* [b]. There is no scanning or filing, saving her even more time!

01

02/a

02/b

TIP

Make this a daily challenge with a colleague or coworker. Think of it as Drawing Tennis. Cleverness and thought counts. Limit passes back and forth to four to make the drawing size manageable. Take time at lunch to look these over and talk about them!

3 | SETTING GOALS

IDIOTS' BOOKS

03 Swanson, the writer, collaborates with Behr, the illustrator, to make satirical illustrated picture books for adults, yet he harbors "a deep-seated hankering to make images—an impulse fueled by the fact that I'm so bad at it." To soothe that yearning, he devised *Matthew Draws*, a project/exercise in which Behr picks four celebrities for him to draw from source photos found online. Swanson says, "The more cartoonish a face (Ronald McDonald, Elton John, Carrot Top), the easier it is for me to make it recognizable. The more lovely and refined (Princess Di, Scarlett Johansson, Julia Roberts), the more I seem to butcher it into hideous anonymity. All my women look tortured and sunken."

04 Once finished, they post his drawings on their idiotsbooks.com blog and, using free survey software, give their readers a chance to guess who the subjects (or "victims," as Swanson puts it) might be. "We always add a fifth question, editorial in nature, such as: 'Which of these folks would you rather be stuck in an elevator with for an hour?'" He says the answers to these questions "are usually as hilarious as the drawings are bad."

05 From left to right, here are hints to the drawing subjects: Can you guess this one? No it's not Conan O'Brien! Can you guess this famous actress? Don't let her accent fool you. It's fake. The couple has a solid following on the web where readers know their story and appreciate the self-effacing humor they bring to their day. Swanson says his practice has "two reinforced truths: 1) I really can't draw, and 2) I love to do it anyway. To this date, no one has ever guessed all four drawings in a single *Matthew Draws* correctly. Perhaps if someone ever does, I'll know it's time to stop."

03

05

04

JORGE COLOMBO

06 At a meeting, riding on the subway, or waiting for a friend at a coffee shop are all perfect opportunities to try this exercise. This 1984 ballpoint portrait of author Miguel Serras Pereira, drawn by illustrator/photographer/designer Jorge Colombo, is a great example of an interesting drawing made in less than five minutes. It was drawn during an editorial meeting of *JL*, a Portuguese magazine, using one of his favorite media—a cheap ballpoint pen. Note the emphasis on the eyebrows and nostrils, perfect counterpoints for the quick line work in the rest of the drawing. By carrying a ballpoint pen and a small sketchbook, you are set to take the Five-Minute Drawing challenge!

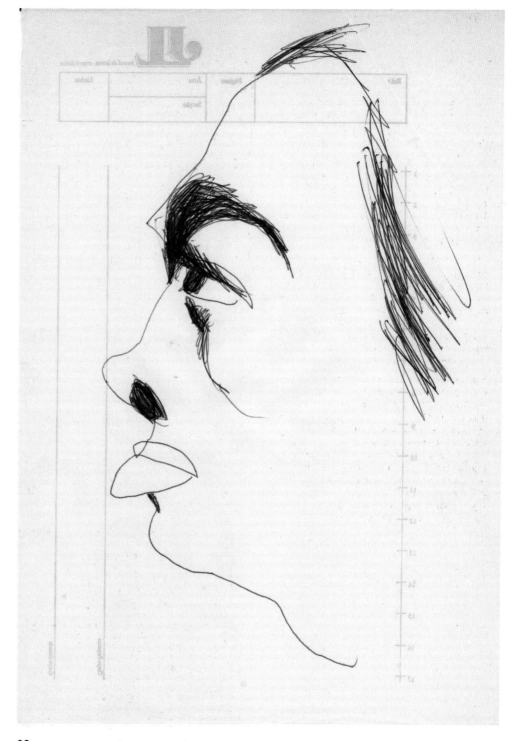

06

27. **ONE DAY, ONE THEME**

Several years ago during my visit to Rome, I realized that recording my experiences there was not possible with a sketchbook. This seems a bit odd, Rome being a center of art history, but the reality was that I was with friends who knew Rome very well (it was my first time there) and they were moving fast! Using my cell phone camera was just right as I captured buildings, sculpture, mosaics, and graffiti.

One morning, I saw a woman in a grey suit walking in front of us wearing an orange shoulder bag. It was striking! As I followed her to catch a shot of her rushing to work, I decided to spend the entire day only photographing things that were orange. It was amazing to have this observational constraint. It helped me keep a keen focus, and it produced a great series of images that range from water pipes to evening gowns.

This same constraint is the basis of this exercise. Choose one theme, one kind of object, and only draw that thing during the course of the day. You can vary your approach to this by choosing an animate or inanimate object, a color, a size of something, things that are scary or make you laugh, or things that start with a specific letter. You can also use synonyms, such as things that move you emotionally versus things that literally move you like modes of transportation. The more

thoughtful you can be, the more you exercise your concept-building abilities.

Illustrator Kelly Lasserre is masterful in capturing the beauty in everyday objects. Her observational skills convey personality and a sense of loving use in inanimate objects. Look close by at your own personal environment for interesting subjects like the pencils on your desk, the shoes in your closet, the marks on your body, spreads in your fridge, sweets in your pocket, or hairstyles on a TV show!

01

KELLY LASSERRE

01 *Shoes*

02 *Twin Peaks hairstyles*

KEVIN VALENTE

03 MICA graduate student Kevin Valente shows his enthusiasm for hot and cold drinks in this sketchbook spread. The variety of colors he used on similar shapes and the commentary added give the page spread its punch.

04 In this example, Valente's line work delineates the pure shape of plastic cups and records their translucent quality. Focusing on one type of material is another approach to One Day, One Theme.

BRUISES, CUTS, SCRAPES & BUGBITES

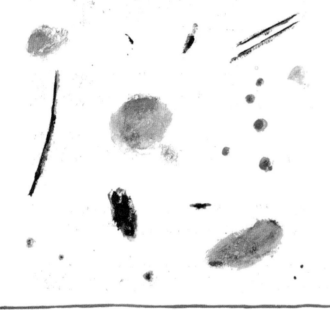

the signs of life

05

06

horseradish

yellow mustard

hot pepper relish

syrup

real butter

black raspberry jam

real mayonnaise

ketchup

mayhaw jelly

strawberry preserves

barbeque sauce

SPREADS IN MY FRIDGE

07

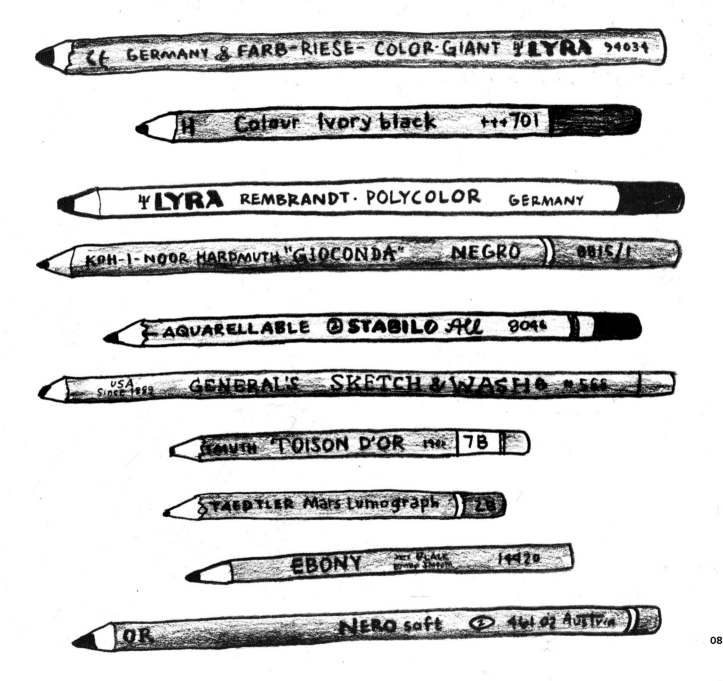

08

28. **MAP YOUR DAY**

Designer and educator Sandie Maxa has always been fascinated with maps and their ability to orient someone to an unfamiliar place. "As a designer, I appreciate the economy of information presented on a small piece of paper and enjoy decoding the symbols, colors, and use of line," she says. "While I was in graduate school, I became interested in using information design structures (including timelines, graphs, etc.) to tell stories rather than just facts. Sketching out my day in the form of a map was an easy way to test out the idea. These sketches led to a series of more complex narrative maps and ultimately my thesis project." This exercise will enhance your understanding of how to order complex information and create unique informational graphics that tell a story.

STEPS

1. Draw a map of your day by creating symbols and icons to represent activities or events, places visited, modes of transportation, etc.

2. Use scale, color, or line quality to differentiate between mundane or daily tasks and unusual happenings. assemble the strip when finished drawing.

3. Consider how the composition reflects your sense of time. Was your day ordered and on schedule; mellow like a lazy river; or chaotic and frenzied with many things going on at once?

4. Use repeated or dashed lines, negative space, or containing shapes to make connections or emphasize active vs. idle time.

VARIATIONS

- Take a detailed day map and convert it into a streamlined day map by organizing the drawings in a graph that charts location, time, or hierarchy (best to worst, biggest to smallest, etc.).

- Use similar types of imagery to tell your story: your day through the type of trees you saw; your day through the foods you ate; your day through logo encounters; your day through the amount of email you answered, etc.

SANDIE MAXA

01 *Smell-o-rama,* This is an image Maxa created in graduate school mapping a day of fire hydrants, trees, and smells.

02 *Highways are for the birds,* Collage, fine-tip pen, colored pencil

smell-o-rama

01

02

03

SARAH JACOBY

03 Frequently traveling back and forth between Philadelphia and Baltimore, graduate student Sarah Jacoby has plenty of things to use as she maps her frantic day at MICA.

DINGDING HU

04 MICA graduate student Dingding Hu is from China. She traveled from Baltimore to Los Angeles over fall break with some friends. She mapped her day through modes of transportation from east to west.

MARTIN HAAKE

05 Martin Haake maps his state of mind, giving hierarchy to individual concerns of the day.

05

04

TIP *Consider mapping smells or other less tangible parts of your day!*

29. CULTIVATING YOUR CULTURE

Designer and educator Brockett Horne set a goal to visit one Smithsonian museum per week for the summer. She notes, "Each Friday, I enjoyed the American treasure of free museums in Washington, DC, which offer insights into art, natural history, science, and even exhibition design. I carried a small sketchbook with no real goals other than to draw what I saw. The best results came from the Natural History Museum's collections of animals: species alive and extinct, from all over the globe. I drew from models, panoramas, skeletons, taxidermy specimens, objects under bell jars, and even from fellow museum visitors." From this collection of sketches, she later produced a series of cards and screenprinted pillows.

TIP *Consider what product is best suited for your drawings and prototype them before publishing.*

01

DOING IT YOURSELF

Making your own products is a great way to personalize your space and see your work come alive. Getting your work onto products can sometimes seem like a hurdle, yet the available online resources are vast and ever changing. Online, examples include letterpress postcards; sketchbook covers; laser-etched leather Moleskine covers; linen, cotton, and silk fabric digitally printed; cell phone and other digital-device cases; limited-edition giclée cards and prints; and full-color offset hard-covered books, to name a few. Offline, small print studio businesses are prevalent, where, for a fee, screen printing and letterpress-equipped studios can be rented.

Since 2008, the number of online producers has risen dramatically, with design and illustration professionals using online resources to expand their creative output. This interest in creative product began with the DIY movement and is now supported by the proliferation of limited-run online manufacturing, indie festivals, online shop options, and payment vehicles. In 2009, according to JWT Worldwide, approximately one-quarter of people ages eighteen to twenty-nine in Australia, Canada, the United States, and the United Kingdom said they would "start their own business if they lose or have trouble finding a job."[1]

[1] Will Palley, www.jwtintelligence.com/2011/12/data-point-generation-gos-entrepreneurial-ambitions-2, accessed November 17, 2012.

cephalopod
320 million
years ago

janassa

PALEOZOIC REEF
STUFF

platysomid

rugose coral

echinoderm

warthia
saundersi

crinoid
stem

HORSHOE
CRAB

BRITTLE STAR

PEANUT
WORM

SANDPIPER

AUSTRALIAN
SPOTTED
JELLYFISH

BROCKETT HORNE

01 To create an artist product, Horne arranged her favorite line drawing into a sympathetic shape and screen-printed it onto a pillow. Other products equally appropriate for this exercise are T-shirts, totes, notecards, etc. For pillows, use pre-sewn cases or sew your own, and make one or create multiples!

02 Horne's sketchbook is filled with rapid line drawings that capture the essential shapes of the creatures she observed.

12

20

14

15

13

WHITNEY SHERMAN

12 *MetaWare* concept page from Baltimore Museum of Art visit

13 *MetaWare* handpainted tile from Baltimore Museum of Art visit

14 *MetaWare* handpainted plate from Baltimore Museum of Art visit

15 *MetaWare* handpainted creamer from Baltimore Museum of Art visit

16

Sketching collections in your favorite museum can produce a variety of unique responses. In this case, sketching dishware at the Baltimore Museum of Art Decorative Arts collection inspired a set of dishes created at a DIY pottery business. Popular with crafters, DIY pottery businesses provide resources that include blank unglazed pottery, brushes (though you might want to bring your own), transfer paper, glazes, firing, and helpful instruction that make it easy to develop your drawing into 3-D, functional objects. Shown here are the basic tools used to transfer your drawings onto the pottery to paint.

17

MATERIALS FOR DO-IT-YOURSELF POTTERY

16 Blank unglazed pottery

17 Dust cloth for clear the surface

18 Pencil for sketching on the blank

19 Tracing paper and transfer tissue to transfer your drawing on the blank

20 Glazes

21 Small brushes

22 Never use an eraser on the blank

Glazes and firing are usually included in the DIY pottery studio cost. The cost of a blank depends on the piece you buy.

19

30. **100 MONSTERS**

This exercise is based on designer and illustrator Stefan G. Bucher's original body count for his Daily Monster website, www.dailymonster.com. "For 100 days, I filmed myself putting a few drops of ink on a piece of paper each day and transforming the resulting blot into a new monster," he explains. Splatters are the basis for a collection of monsters he created. Bucher spends between five and ten minutes on simple monsters, though he'll keep going for as long as it takes if the character demands lots of fiddly detail work. He never plans ahead. Each character is born from what he sees in the inkblot. See what you can do in that same amount of time. Below is how Bucher makes a monster.

MATERIALS

Sumi ink

Paper

Eyedropper or old toothbrush

Can of compressed air

Drawing media

STEPS

1 Put a small drop of ink on a piece of paper. Use an eyedropper, if you have one handy. Or spread the ink with an old toothbrush.

2 Use the compressed air to spray the ink outward in any direction. (Be sure to use the fine straw nozzle that comes with most cans. Don't be shy, either! Really blow on the ink!)

3 Turn the paper until you see either the full creature or just a part to get you started. (If you get stuck, pick a spot to put an eye, and go from there.)

4 Start drawing.

5 Don't worry about mistakes. Change the creature to work with what you've already drawn. Improvise!

6 Don't worry about who this monster is. Post it on the Internet and others will happily let you know.

7 They don't have to be monsters. Anything within the space of that paper is your world!

8 Make 100 drawings. You'll be amazed what happens whenever you think you've run out of ideas, but keep going anyway.

The blogging aspect of Bucher's self-driven project was key to its success, and it's the reason the Daily Monster continues to flourish today. Posting each creature online garnered him a loyal and passionate following that encouraged him to create more and more characters. "Every night I posted the result on my website and stood back in wonder as visitors from all over the world told me the amazing stories behind each creature," he says. This has led to other things, as well. Bucher's Daily Monsters have since grown into a book, appeared in an online commercial for Honda, and led to animated sequences for the PBS show *The Electric Company*.

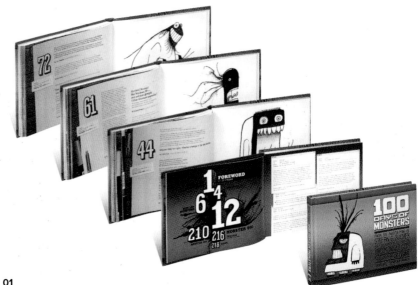

01

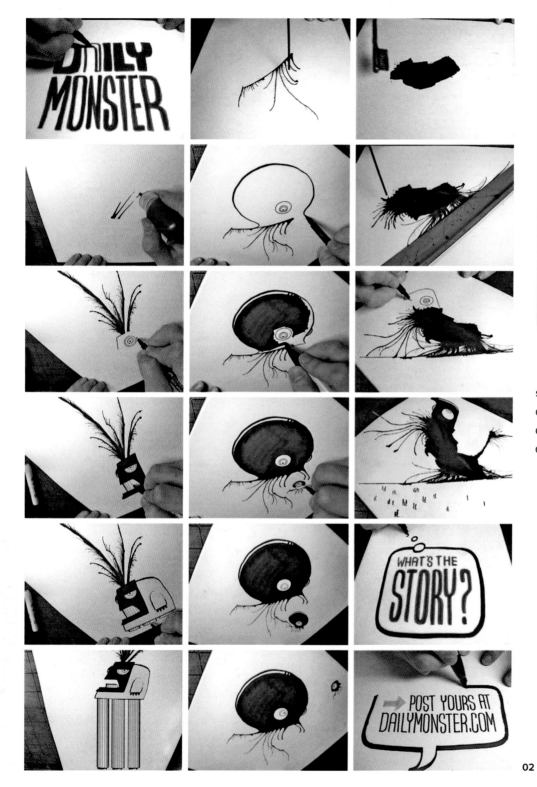

03

STEFAN G. BUCHER

01 *100 Days of Monsters* book

02 Daily Monsters clips

03 Daily Monsters website

02

3 | SETTING GOALS

STEFAN G. BUCHER

04 A Daily Monster

05

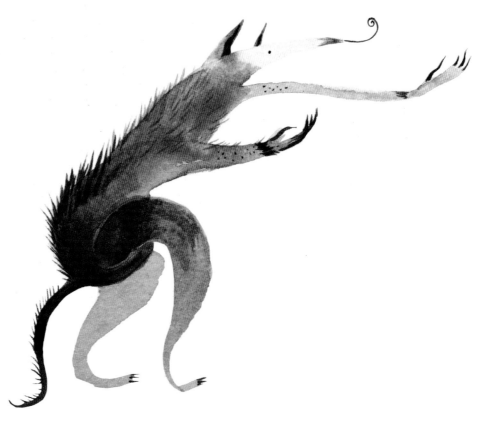

04

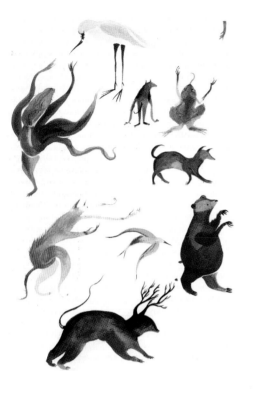

SARAH JACOBY

05 MICA MFA in Illustration Practice student Sarah Jacoby tries her version of the 100 Monsters exercise. Starting with a small pool of watercolor, she moves outward to a simple shape, then adds details until she's satisfied with the monster. Note that she stayed in a somewhat monochromatic palette. Using the same method, she created a small universe of her own monsters.

WORKING THE WEB

Not every designer is a web genius, so it's no point of shame to get your creative ideas out there using a formatted blog site. WordPress is great if you want to do a little retooling of the site's visual presentation. WordPress, Squarespace, and Blogger rank highest for promotion and tracking tools and technical support. Blogger is more limited in customization, but it's perfect if you have zero-to-little interest in learning even basic coding skills. TypePad, though high on tracking tools, is slightly lower in design tools and ease of use.[1] Squarespace is equally high in design tools and ease of use as WordPress, but it ranks a few steps lower in tracking tools and tech support. Blogger is both a hosted upgradable site and a blogging service with customizable pages and is similar to WordPress in the time you'll need to invest in customizing things. Some alternative sites offer additional features, such as Tumblr's photoblogging, which has community-generating capabilities similar to those of Facebook; the ability to import from Twitter, RSS feeds, and other services; and the choice of numerous themes. Posterous allows posting of images, audio, video, and text; has multiple themes; and lets you simultaneously post to Facebook and Twitter. Speaking of Facebook and Twitter, if you are not interested in saying a lot but are interested in showing the world what's up with you, Twitter and now Facebook give you a way to say it in 140 words or less, and with hashtags you can instantly reach an audience of people even if they are not following you. Your Twitter account can also be linked to your Facebook account, so your posts appear in two places at once! And on Facebook, you can create a page exclusive to your personal photos and meanderings, but as with all Facebook pages, it will have ads. Instagram is an image-centric way to engage. As with Twitter, people can "favorite" and follow your Instagram postings.[2] You can keep up with new services and their benefits to find something right for you at *www.toptenreviews.com* and *www.pcmag.com*.

[1] TopTenReviews, "2013 Blog Service Comparisons," TechMediaNetwork, http://blog-services-review.toptenreviews.com, accessed November 2012.

[2] Dave Drager, "5 Best Blog Sites Other Than WordPress and Blogger," www.makeuseof.com, January 24, 2010.

31. **365 DAYS OF DRAWINGS**

It's one thing to start a sketchbook and perhaps finish it over a course of undetermined time; it's another thing to commit to making one drawing a day and then sharing it with the world! This exercise is really a challenge to set goals and follow through—it's the equivalent to be a drawing long-distance runner. You'll start out full of spunk, and eventually hit a wall. You'll want to stop or cheat and skip a day, but don't do that! Stick with it, muscle through, and see what you come up with. It will be your no-cost postgraduate degree, especially if you put it online and get comments. Three hundred and sixty-five days is a long time to commit, but a short time to realize a change in your drawing and idea-making confidence. Here are examples of artists who made a commitment, large and small.

In late 2009, painter Sam Lacombe's second son, Simon, was born. He found he had precious little time for his usual detailed paintings of signage and urban landscapes. He'd also given up his studio, and with little time and space, "I decided to devote myself to drawing a series of self-portraits in the coming year and blogging the results," he says. Lacombe gave himself these perimeters:

1 Start on January 1 and complete the drawings and blog on December 31.

2 Draw and upload daily: "There can be no drawing ahead or missed days made up later!"

3 Use a variety of techniques.

Challenges arose along the way, mostly involving travel. Day planners, hotel stationery, cocktail napkins, and wedding invitations were used out of necessity, but he felt they enhanced the autobiographical nature of the project. He worked with graphite, pen, charcoal, eyeliner, oil and acrylic paint, scratchboard, color pencils, pastel, ink, and digital media, using them in unconventional ways whenever possible. He also used mobile apps like CamScanner and BlogWriter so he wouldn't miss a day.

Lacombe notes, "I discovered that after a few months I was able to get good results from inventing the drawings, and in what turned out to be one of the biggest surprises to me during the project, I found that many of the invented drawings were actually a much better likeness! To date the blog has been visited over 2,200 times, and viewed in over 50 countries."

01

Designer Daniel Horowitz created images (pages 112-113) using old notes and receipts, Japanese newspapers, paint, ink, magazines, and old engravings. Why start this project? Why keep it going? Horowitz has two reasons. "I want to rediscover working with my five senses. Designing analog is governed by some of the same principles as digital, but feels, smells, and sounds very different," he says, adding, "I also need to get my ass away from the computer!" That is something every designer can relate to and certainly one of the goals of this book. To ensure the project kept going, he also published daily to a blog. Horowitz says that blogging the project gave him a sense of urgency and commitment. "Once it was published there was no changing it. People's responses gave me the courage to follow through on the project, although in the beginning I wasn't really planning to show anybody."

His efforts to date have resulted in him publishing all 365 drawings in a beautifully produced limited-edition book, *365 Drawings*, with a bonus poster and an interview with Pulitzer Prize–winning author Lawrence Weschler, and a separate giclée print edition. It also spurred his next marathon project, a drawing for every page of the novel *The Master and Margarita*, which can be viewed at drawingdujour.tumblr.com along with all 365 drawings.

02

SAM LACOMBE

A COMMITMENT TO DRAWING

Goal-oriented drawing projects can be found online on blogs, on image-gathering sites like Pinterest, on Twitter, and on fundraising sites like Kickstarter. There are also books, the other monument to a long-term commitment project. Here are just a few of the many promises people have kept to drawing.

CF52

Designer and illustrator Craig Frazier tackles one drawing a week in highly inventive ways. The topics are varied, and his material uses and concepts are notable and inspiring. His website is sophisticated with great navigation.

MINIMONDAY

Visual essayist Meryl Stebel turns a keen eye on herself and everything else around her, providing images and commentary each Monday on her blog.

TEN PACES AND DRAW

Ten Paces and Draw is more than a blog you can contribute to; it engages contributors in unique collaborations with others. Draw a sketch on an assigned theme, submit it, then your sketch gets traded for another—the one you will bring to final art! It's a plus/plus experience developed by Alyssa Nassner and Rachel Dougherty. The operation has grown to include cohorts Natalie Andrewson and Andrew Morgan.

365 DAYS OF DRAWING

Alexa Tait's charming sketchbook Tumblr is full of imagery and hand lettering.

365 DAYS TO DRAW
@365daystodraw

Designer/illustrators Laura Worrick and David Elden of WE Design Studios provide daily tips on drawing on Twitter. They also offer 30-day, 60-day, 90-day, and 365-day courses to inspire you to draw.

100 DRAWINGS

Mitsu Okubo used Kickstarter to fund his project to publish his drawings for an exhibition.

1000 DAYS OF DRAWING

Kickstarter also funded Chris Piascik's project to produce a book showcasing all 1000 drawings.

365 DAYS

Julie Doucet's book, published by Drawn & Quarterly, is personal, mundane, and engaging. Here, it's the little things that count!

01

DANIEL HOROWITZ

01 *Drawing of the Day 355*, 365 Drawings

02 *Drawing of the Day 96*, 365 Drawings

03 *Drawing of the Day 98*, 365 Drawings

04 *Drawing of the Day 299*, 365 Drawings

02

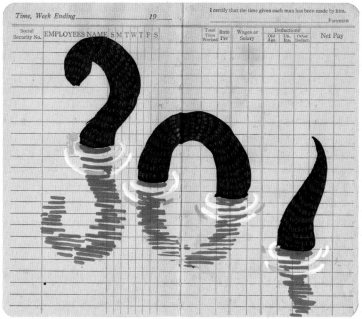

03

04

32. **CONSTRUCT/DECONSTRUCT** (LETTER)

The objective of this exercise

is to conceptualize ideas from shapes with the goal of bringing a narrative of sorts to letterforms, to animate them in one image. Use any drawing implement you prefer. You will be working in black and white, so color is not needed here. To begin, choose one character or letterform to execute in its correct form. This is the "constructed" part of the exercise. Look for letterforms with some character in their shape, such as in headline or display typography. Many times, old magazines or newspapers or product labels have interesting lettering, especially from Victorian times. The library affords a wealth of materials in this area.

STEPS

1 Make a copy of the letter and enlarge it to fit on an 8 ½ x 11-inch (21.6 x 28 cm) sheet of paper.

2 Render the letterform as exactly as possible—tracing is allowed, but it is best if your drawing is done by eye or using graph paper. Think of the letter shape as an object in a picture and use the same skills as in observational drawing. For instance, an "h" looks like a chair, and an "A" looks like a roof of a house. Keep your eye on the proportions of the letter parts and of the negative spaces.

3 When you have finished drawing that letter you have finished the "construct" step.

4 Using the same character and a new sheet of 8 ½ x 11-inch (21.6 x 28 cm) paper, destroy it, take it apart, or rearrange it. This is the "deconstruct" part of the exercise. Leave some aspects of the constructed form so that we can know which letter it is. Try to deconstruct it in some way that pays attention to the form, yet reimagines it. If you deconstruct too far, it will not be legible.

SUGGESTIONS

• Take apart the letter as if you were taking apart a shirt at its seams, moving each part into another arrangement, but making sure we can still know the letter.

• Create a conceptual interpretation of the shape of the letter. This might be a response to the styling of the letter; for example, a Gothic letter as melting candle wax.

• Think of what the letter shape makes you imagine. What does the shape look like and what action can it take?

• Think of the letter as an animate object. How could you deconstruct it? If you could look inside, what shape would be beneath? Can this be reduced to smaller parts?

• Can you deconstruct the letter based on perspective?

01/a

01/b

TIP

Let intuition guide you in this exercise! Go for the structural perfection of the original letterform. Be imaginative when you deconstruct it. Conceptual approaches are encouraged.

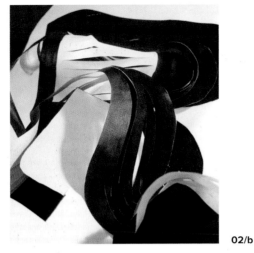

02/a

02/b

03/a

03/b

04/a

04/b

EMMA MAATMAN

01 Illustrator Emma Maatman chose a Cyrillic "Ef" letterform **[a]** derived from the Greek letter *phi* to construct in beautiful proportion, then deconstructed it by blowing out the side **[b]**. Rather than utilizing the sound of the letter in its native tongue as the impetus for her idea, she was inspired by the shapes and what they reminded her of. Seeing potential in the uppermost part of the form, which to her resembled the plunger of a blasting machine, she deconstructed the form by using its own parts to blow itself up.

KIM GIM

02 Designer Kim Gim use a capital Clarendon "R" **[a]** as her "constructed" letter. This letter, an English slab-serif typeface created by Robert Besley and first published in 1845, has really great straight and curved shapes to it. In order to deconstruct the letterform, Gim decided to remove it from the normal picture plane by cutting the shape out, draping it, and then photographing it **[b]**. She could have gone on to sketch from this photo to take the process even further. This example is shown to suggest that the use of a camera in the process of deconstructing can be very useful.

PAIGE VICKERS

03 Illustrator Paige Vickers chose a Cyrillic "Zhe" **[a]** because she admired the variety of forms in the lettering design and the symmetry of its shape. One of the benefits of working with alphabet letterforms from a language other than your own is that you can examine the letter shape abstractly, freeing you from the linguistic meaning and seeing pure shape. Vickers saw this letter as an organic form, a branch and leaves that she could then imagine deconstructing by having caterpillars eat the leaves with half of the letter gone. Because the eaten leaves are a familiar sight, Vickers did not need to show the caterpillars, making the image more sophisticated **[b]**.

YAO LI

04 Illustrator Yao Li discovered this letter "Z" **[a]** in one of my many books on historic typography and lettering. He was struck by the lettering form, which he captured in his marker rendering of the "constructed" letter. The form reminded him of fangs and Gothic drama. To deconstruct it, he imagined the form melting like a candle in Dracula's lair **[b]**, giving the formerly flat form some dimension.

33. **BLIND DRAWING** (WORD)

This exercise is all about breaking down formal structures to see new shapes. Although you are being asked to use letterforms, you could certainly look at a face, an animal, or a vase of flowers and use the same technique to take your mind away from what you think an object should look like and allow your hand to freely interpret shapes. When looking at shapes we readily know, such as letterforms or faces in slightly rearranged formations, we can observe new relationships in the imagery, much like Juan Gris did in his 1912 Portrait of Picasso, or exercise a deconstructivist vision as architects have used that encourages freedom of form and complexity rather than strict attention to functional concerns and conventional design elements.[1]

MATERIALS

Computer and printer

Paper

Drawing media

STEPS

1. Print out five different words in the typeface Helvetica that are four or five letters long.

2. Stare at the words, looking at the outside shape of each letter, the inside shapes, and the shapes in relation to each other.

3. Close your eyes and first draw the inside shapes (the counters) of the letters going left to right, then draw the exterior of each letter in the word going left to right. This process will inevitably deconstruct the words, but each will be surprisingly legible.

4. Continue to the next word, drawing each word one by one.

5. Make multiple versions of this exercise by changing the words. See exercise 35 for ways to use the results of this exercise.

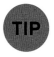

TIP *Use a comfortable chair and draw on your lap with your arms to your sides; you will have more control of the marks.*

[1] www.merriam-webster.com/dictionary/

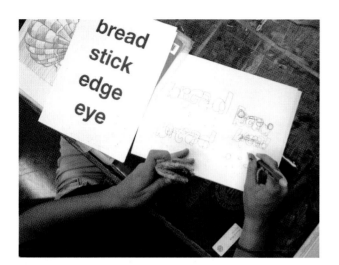

01 These examples of Word: Blind Drawing show how the clear letterforms of the typeface Helvetica can be visually redefined. Varying the weight of your drawing tool can enhance the variables of this exercise.

01

34. **CHANNELING MATISSE** (TEXT)

In the early 1940s, the renowned French artist Henri Matisse underwent surgery that confined him to bed as well as a wheelchair. During this time he did not stop working; rather, he employed a unique technique that allowed him to work while lying in bed. He attached a charcoal to the end of a 5- to 6-foot (1.5 to 1.8 m) bamboo pole and drew his marks to paper affixed to the wall of his room. From these marks he created some of his most modern work—the gouaches découpés, or cut paper collages, that came to be reproduced in his book *Jazz*. As the years went by, and his ability to stand for extended periods became limited, he continued the practice of using a long stick to draw, including his work for the glass windows and interiors of the Chapelle du Rosaire in Vence, France. For this exercise, we are using the technique of Matisse, but rather than drawing figures and plant forms, we will draw letterforms. The goal of this exercise is to allow mistakes to happen with the letterforms, to push the boundaries of legibility, and to celebrate the textural aspects of lettering.

MATERIALS

Drawing media

Long stick

Large piece of paper

Drop sheet, if using wet media

STEPS

❶ Choose a passage you are familiar with. It should be about one paragraph long. If you have a passage longer than that, then do the paragraphs in separate sittings.

❷ Attach a drawing tool that will produce a medium- to heavy-weight mark to the end of a stick. Make the stick at least 24 inches (61 cm) long, preferably 36 inches (91 cm) long. Matisse used a much longer stick, so once you have mastered the shorter stick, try one that is longer.

❸ Attach a piece of paper to the wall. If you are using a wet medium, put a drop sheet on the floor.

❹ Holding the stick with the drawing tool out at arm's length, begin to write the passage you have selected onto the paper, and continue until done. You will discover it is difficult to control the letterforms. As a result, with practice, you will develop a set of marks that are new, based on your disability, to draw as you normally do as a remarkable texture of the text emerges. Celebrate those marks.

KIM GIM

01 Two examples by Kim Gim of how the texture of the passages can be used. Detail sections of the passages were scanned, enhanced, and combined to create dynamic digital collages. The textures can become part of a digital archive to use in image making, as printed texture for collages, or as digitally printed fabrics for handmade goods.

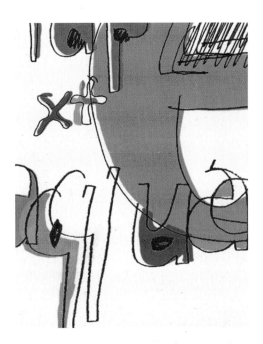

01

02

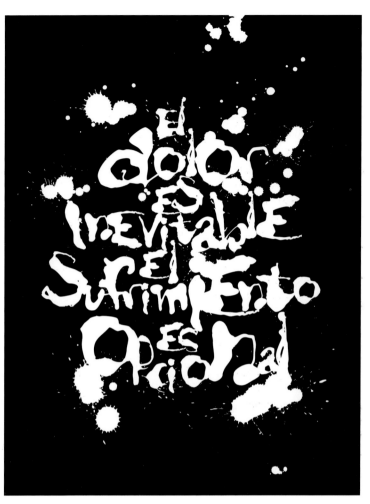

04

03

ASHLEY JACKIMOWICZ

02 This example by Ashley Jackimowicz conveys intensity through the use of color and multiple overlays of the passages. The writing was done in printing and in script, and the orientation was rotated. Parts of words emerge, suggesting a message.

LARA KAMINOFF

03 Kaminoff, shown here, is taking the exercise to heart and trying an alternative: drawing with both arms extended and writing with both simultaneously. Whereas the previous examples had overlaying letterforms created digitally, here the student is overlaying directly using different color markers.

JUAN CARLOS VÁZQUEZ PADILLA

04 Using a free-form method of lettering, one where his ability to fully control the shapes is removed, designer/writer/educator Juan Carlos Vázquez Padilla created this emotive hand-lettered message *El Dolor es Inevitable El Sufrimiento es Opcional (Pain is Inevitable Suffering is Optional)* using dripped liquid media, then reversed the dried image digitally for greater impact. With this one choice, the lettering in white is illuminated against the black background, much like the message's meaning.

35. **DIGITAL COLLAGE** (LETTER/WORD/TEXT)

The preceding three exercises

have taken the three elements of our written language—the letter, the word, and text—and shown you ways to push their limits by seeing each differently through concept, surface, and legibility. In this exercise, you are asked to use the by-product of your efforts to combine whole results or parts of your results to make new images using digital software.

MATERIALS

Scanner

Computer with Adobe Photoshop

Printer

STEPS

1 Make high-quality scans of each piece (300 dpi) at 100 percent. Develop a labeling and filing system so that as you acquire more textures and images, you can find the ones you want easily.

2 Open your first file in Adobe Photoshop and save it as a new file name. This will preserve the original file and allow you to manipulate the newly named copy any way you want without fear of losing it.

3 Select All (command + A) and then Colorize it (command + U) by clicking the Colorize box at the lower right corner of the dialog window. Use the slider bars in Hue, Saturation, and Lightness to shift the color until you get something you like.

4 Find another scan from your exercises that you want to use, open it in a separate window, Select All, then Copy (command + C) and Paste (command + V) into the file you have just colorized.

5 At the top of your screen, find Window and go to Layers to open the Layers window (if it isn't already open). At the top left you will see a drop-down menu that reads Normal. Click and hold to get the options and select Multiply. The layer you just brought in will be transparent.

6 Repeat steps 3 through 5 as much as you wish, until you have an image you like. You may wish to change the orientation of the files you bring in. You can do this by selecting the layer you want to affect in the Layers window (make sure it is highlighted), Select All, then Transform (command + T). You will see small squares appear at the corners of the picture. Place your curser outside the image frame and move it toward a corner square until a curved arrow appears. Once you see it, click and turn the window to the orientation you want, then double click inside the picture to release the Transform.

7 If you want to preserve this layered file for future use, do a Save As and name the file what you had planned (example: HappyPassage) and add the word "Layered" at the end of the file name (example: HappyPassage_Layered).

8 Once you have the image you like and have saved the layered file separately, or have decided not to save a layered file and opted out of step 7, go to the uppermost right-hand corner of the Layers window. Click on the icon that looks like a stack of papers until a menu appears. Select Flatten Image and the layers will compress to one. Save the file without the word Layered, if you have chosen this step. Make sure you have saved the file to a location you want, either a special folder or on your desktop.

9 Print out your digital collage.

10 If you want even more choices, scan the portions of the drawn letters at a higher percentage to get the same marks larger yet still in high resolution. If you manually enlarge your image, you are reducing the quality of the resolution.

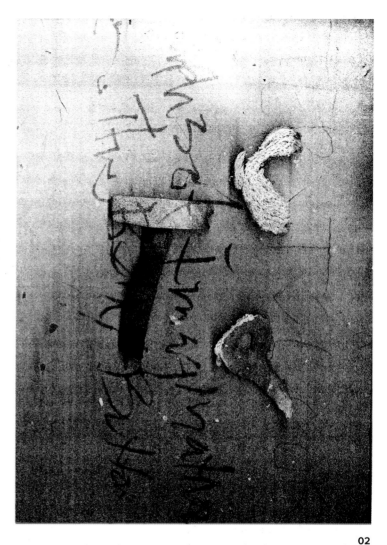

01

02

KRISSY DIGGS

01 Student Krissy Diggs used elements from all three exercises as materials for these two compositions [01], which include digital manipulation of originally created materials, overlapping, image rotation, repetition, and color changes.

STEVEN JOHNSON

02 High tech meets low tech in this composition by student Steven Johnson. He took the assignment in a different direction, relying on the black-and-white aesthetic of a photocopier combined with digital technology to overlay lettering.

ALTERNATIVE: PHYSICAL COLLAGE

Make high-quality scans of each piece (300 dpi) at 100 percent. Develop a labeling and filing system so that as you acquire more textures and images, you can find the ones you want easily. Print out the textures onto different types of paper. Keep a box or file of these printouts for future use. Cut and assemble as you would a regular collage, or take a printed sheet and run it back through the printer using another file or upside down using the same file. Be experimental in trying different combinations, or use unusual papers such as ledger sheets cut to size or pieces of newspaper.

ALTERNATIVE: DIGITAL FABRICS

Create the image you like using elements from exercises 32, 33, and 34. If you want to print a pattern that is repeatable, refer to exercise 13. If you want a design that will appear on the front of a shirt or bag, create your image to the size you need and go to the resource most appropriate to your skill level. If you sew, then a digital fabric printer like Spoonflower.com or Iolabsinc.com will allow you to print on small pieces of fabric such as a fat quarter or yard to use as an appliqué or to construct a small bag from scratch. If you do not sew, then consider using an online service like CafePress.com or Zazzle.com where you can purchase a one-off item using your artwork for yourself, for gifts, or for sale. Or consider sites such as Society6.com to post your work for others to purchase with a portion of the cost coming back to you.

03

04

GUIDO SCARABOTTOLO

03 Guido Scarabottolo's poster for the Italian Graphic Designer's Society AIAP commemorates the 150th anniversary of Italy's unification, and is a brilliant example of lettering ingenuity. To make these unique numerals, he wrote the numbers 1, 5, and 0 fifty different ways, then digitally overlapped them. The poster concept celebrates the unification while alluding to the differences within. He used pencil, pen, and brush to make the numerals.

04 Scarabottolo's mixed-media poster *Wasting Some More Time*, designed and illustrated for D406 Galleria d'arte contemporanea in Modena, Italy, required a bit of disorder in the layout to convey the concept of the exhibition. His playful shapes and letterforms are exuberant. They make a counterpoint to the static figure, as well as create a sense of ground, or suggest a shadow.

JACQUELINE MCNALLY

05 Jacqueline McNally's cover art for the *Grow Old* EP by Katie Buckley is shown here as the original art, front and back, and the digitally colored art, front and back. McNally's charming naturalistic letter-forms and border art tell a narrative through small details hidden in the landscape—just the right blend of concept and form for the artist's musical offerings.

05

06

07/d

07/c

07/b

TIP

Consider whether hand lettering is appropriate to the project. Take time to do research on how others have combined lettering and images together successfully.

07/a

BOMBOLAND

06 Italian illustration and design studio Bomboland created this poster that cleverly uses the highway to create ribbonlike headline lettering that reads fate.

MATT LYON

07 Matt Lyon's lettering is a visual foray into shape and texture. Lyon has expressed small narratives with each of his lettering compositions. *Silent Words* [a] flaunts its illegibility with shape and incredibly bright colors. *Sad Words* [b] is a visual contradiction of flowery letters and a laundry list of hopelessness. *Don't Wake Up* [c] brings home a message of teen angst with aged tape, weary-looking notebook paper, and ballpoint-pen lettering. *Do It Now* [d] has a playful exuberance that comes with the multidimensional, highly patterned upper- and lowercase hand-drawn letters. Whether simple or complex, Lyon excites our eye with endless variety.

36. **LETTER AS OBJECT**

The goal of this exercise is to observe how letterforms can become pictorial, then try to make a letter as an object of your own.

MARIAH BURTON

01 Canadian illustrator Mariah Burton created this amusing alphabet from familiar and realistically placed elements. Part artwork, part photographically captured materials, each letter takes the viewer to a unique place conceptually, and makes an eclectic collection to rearrange.

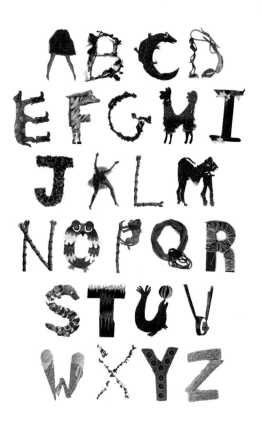

01

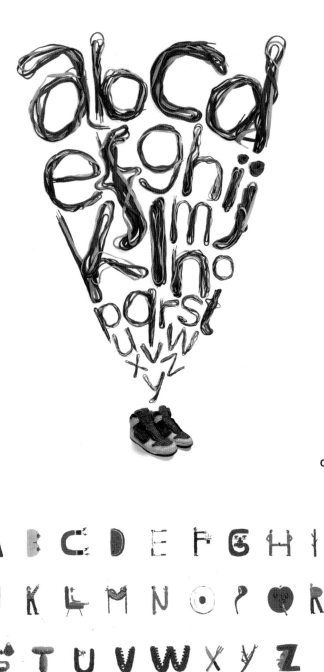

02

03

NICK ILUZADA

02 Illustrator Nick Iluzada loves sports, especially soccer. He gave his alphabet an orderly, yet exuberant sensibility through the arrangement of laces in relation to the shoes that create a visual anchor to the composition.

GERARD ARMENGOL

03 Spanish illustrator Gerard Armengol used personal memoir, humor, and desire to create his semi-auto-biographical letter.

MARK NOTERMANN

04 Designer Mark Notermann uses a single yellow shoelace in the same way one might use a pencil line to write each letter of the alphabet in script.

ZOE KELLER

05 Zoe Keller's one-of-a-kind script letters are both fluid, like the precooked batter and colored by the skillet they were poured on to. The letters were prepared for the final critique/breakfast meeting of my HandLetters course. Each of the designer and illustrator students contributed foodstuffs in letterform.

ANA BENAROYA

06 New Jersey illustrator Ana Benaroya likes to make strong visual statements with her work. For her alphabet, she used every part of the horse, stretching visual believability to the max to construct her alphabet.

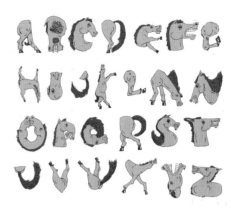

06

NA KIM

07 Delicate erotica forms the inspiration for this alphabet. Illustrator Na Kim used hair and body color to give a gracefulness to certain less-than-graceful postures.

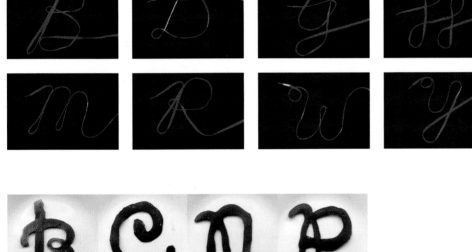

04

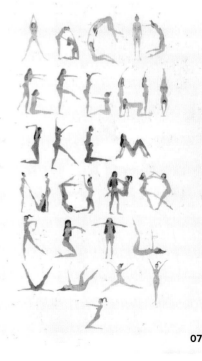

07

05

FINDING YOUR LETTERFORMS

JACQUELINE MCNALLY

08 This alphabet is constructed from etching images from an anatomy book. By setting out the constraints of not altering the anatomical forms except by multiplication, illustrator and artist Jacqueline McNally had to be keenly observant to find all twenty-six letters of the alphabet.

ALISON CARMICHAEL

09 British illustrator Alison Carmichael mimics the roots of the beet for this *Growing Your Own* guide advertisement for the *Guardian* newspaper. She draws a clear distinction between suggesting the root's forms without losing the legibility of the ad's message.

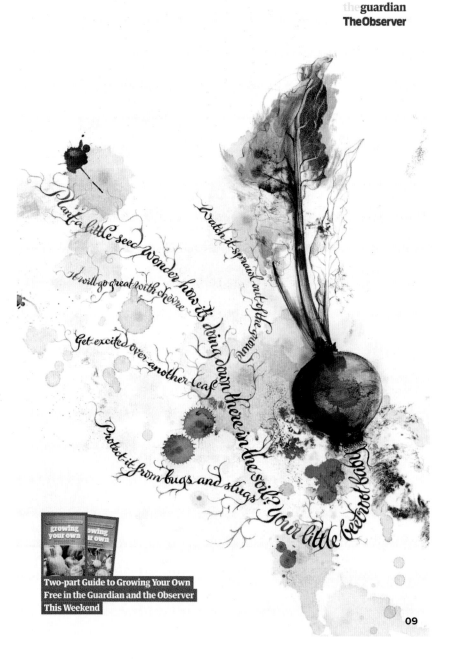

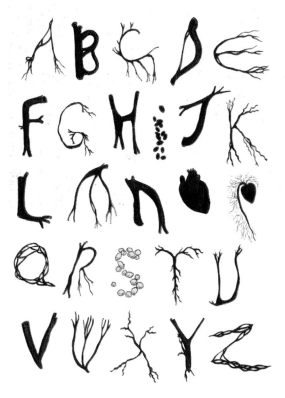

08

09

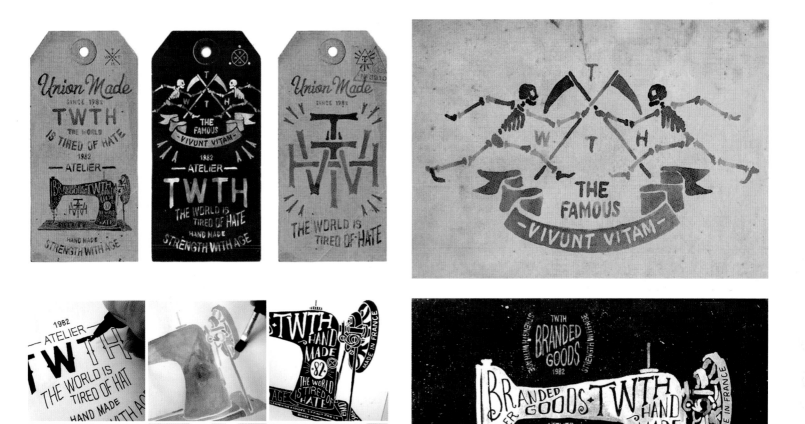

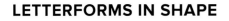

LETTERFORMS IN SHAPE

BMD DESIGN

10 The French firm BMD Design blends corporate message, social philosophy, and form to repre- sents aspects of the Atelier brand identity. This series of images shows the hand-painted lettering and imagery.

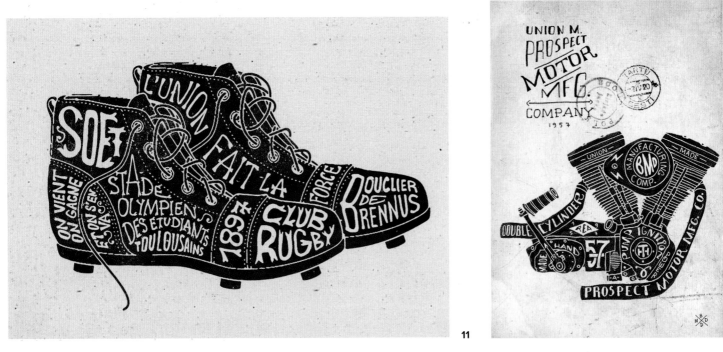

11

13

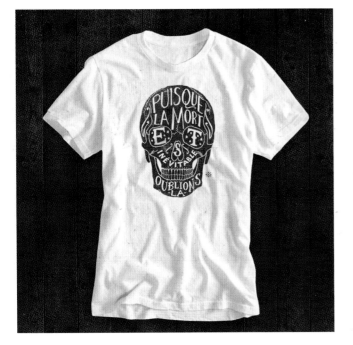

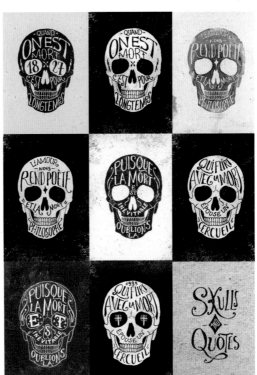

12

CONTEXTUALIZE YOUR LETTERFORMS

BMD DESIGN

11 BMD Design put a slightly Victorian spin on this image for the Stade Olympien des Étudiants Toulousains (SOET). Along with these rugby shoes, BMD Design also created football, helmet, and team monograms, deftly wrapping each form with identifiers of the group.

12 Each smiling skull has a quotation by a notable writer, such as Eugéne Chavette, Pierre-Georges Tamini, Georges Santayana, and Stendhal, concerning topics on love, life, and death. BMD Design has made these highly graphic lettering designs into apparel available online at Society6.com.

13 Unlike the rugby shoes, BMD's lettering for Prospect Motor Manufacturing Company is mechanical and bold.

ALISON CARMICHAEL

14 Through color and form, Alison Carmichael's lettering unquestionably asserts this advertisement product—chicken so fresh you'd think it just came from the farm. It's simple and eye-catching, cleverly using the upper parts of the "W" to create the chicken's comb.

15 Carmichael used the familiar physical elements of a school desk, pen-carved letters, ballpoint pen, and schoolyard name-calling to locate the message in a time and place that everyone can recall as an emotionally distressing period.

YAO LI

16 Yao Li's concept combines the literalness of meat and meat as a metaphor for an unrespected person for his digitally produced book cover. An interesting effect of the combination is an implied boldness of the book's subject. The handwritten subtitle lends a personal air to the design.

16

14

15

DRAWINGS ON WRITING

On the far end of the Letter as Object concept is the book *Drawings on Writing* by various artists, a collection of black-and-white drawings based on the concept of text and illegibility. The book's editor, Dutch-French artist Serge Onnen, selected written works from historical figures, contemporary artists, and anonymous ephemera. This is the third book in the series. The first book focused on faces, and the second book was on geology. This third edition is billed as "100% text, 99% illegible."

37. **WORD CHAIN**

I learned this exercise from illustrator Henrik Drescher and his partner Wu Wing Yee one evening on a train returning home from Washington, D.C. Drescher wrote a simple word on a piece of paper, drew a circle around it, and passed the paper to me, explaining that I should add a word that conceptually came from the first word. I did and passed it to Yee, who knew this game well. Both Drescher and Yee played this game with rapid speed. I soon learned that our words in circles would form a chain that meandered around the page until the last word eventually joined up with the first word!

Seeing this coming, I wondered how in the world we would bring the chain of words to form a complete circle, yet it did, and it read as a delightfully freewheeling expression. Not only that, but the shape each game created was unique. Drescher notes, "This exercise was created as a kind of game between Wing and I. We liked the organic shapes that grew from the words, and the less attention we paid to the 'design' of the page, the better the shapes were." Lettering style, sizes of circles, the nature of the word relationships, and more add visual interest to this exercise, and diverting your attention away from how it "should" look ensures surprising visual results.

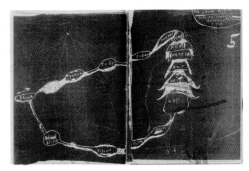

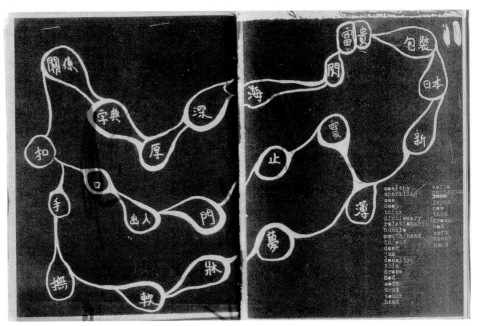

01

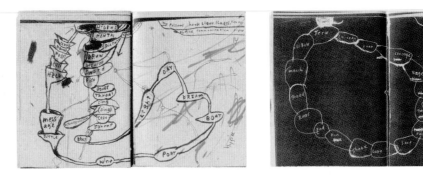

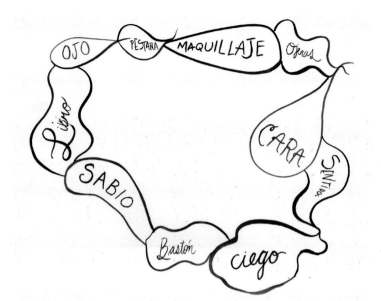

02

HENRIK DRESCHER & WU WING YEE

01 Word chains by Drescher and Yee that combine Chinese and English, languages they both speak.

LISA PERRIN & VALERIA MOLINARI

02 An example of a word chain in Spanish by two of my MICA graduate students.

WHITNEY SHERMAN

03 Word chains can also connect in multiple directions or take on shapes that reflect the subject of the chain.

03

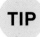 **TIP** *Don't try this exercise if you are sleepy and playing with highly intellectual people!*

38. WORD STACKS

This exercise is playful, spurs the imagination, and develops conceptual thinking through random combinations of words, specifically an adjective, a noun, and a verb. This exercise first came to me through British illustrator Julian Allen while he was teaching at MICA as part of his Concepts course. The directions below are guidelines, so you can follow them point by point or adapt the concept to suit your own purposes.

MATERIALS

Twenty-five 4 x 5 inch (10 x 12.5 cm) blank index cards

Scissors

Pen

Drawing media

STEPS

1. Take twenty-five 4 x 5-inch (10 x 12.5 cm) blank index cards and cut them into thirds. You now have three stacks of twenty-five cards. [01]

2. On the first stack print one adjective on each card. Try to think of a variety of descriptive words that relate areas of science, nature, beauty, temper, or color.

3. On the second set of cards, write twenty-five nouns. Again, use a variety of word types. Don't try to match them to the adjectives.

4. On the last stack, print one verb on each card. Think of the most simple and outrageous things you can, from a rhinoceros to a thumbtack! [02]

5. Shuffle the cards within their stack, but don't mix the stacks! Place the stacks face down and choose the top card from each stack. If you are doing this exercise with others, take turns choosing cards. You may wish to put a rubber band around the stacks to keep them in order. [03]

6. With your three cards in hand, arrange them so they read like this, for example: DEVILISH / BOOK / LAUGHING. If your language assembles sentences differently, adjust the order accordingly.

7. Now, get to work drawing an image suggested by your Word Stack. You may want to add a background to the image, multiply the number of Devilish Books Laughing, or keep your drawing solitary. [04]

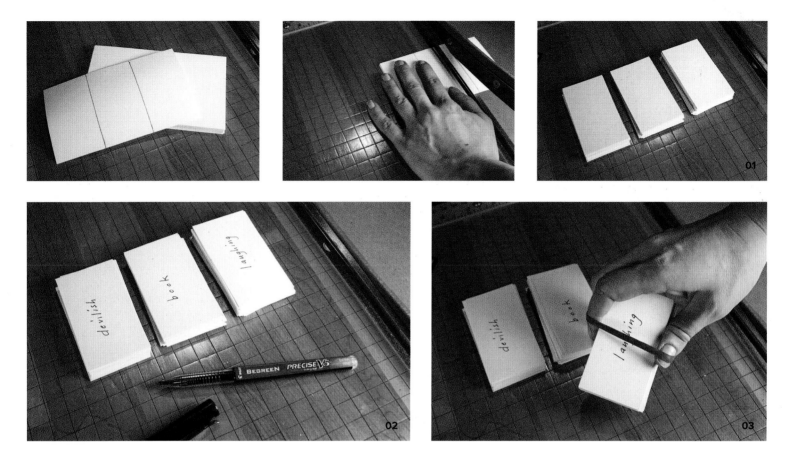

39. **LUDICROUS LISTS**

Illustrator and educator Jaime Zollars developed this exercise for herself one day, using the rules of improv, when she was looking to create some new personal work. "Listmaking is another way of brainstorming, and can lead to unique visual ideas," Zollars notes, but here you will create a unique list theme and respond with an off-the-cuff set of answers. The premise fit right in with her fantasy-based imagery, and gave her a way to uncover images she might not have found otherwise. The first step in this exercise is to open your mind to free-form thinking. All logic should be abandoned and nonsense welcomed. Think of unlikely things and pair them together. Give yourself no more than a few minutes and force yourself to write at least twelve to fifteen answers. Do not think too hard (or barely at all)—just be willing to create a flowing nonsense list.

The next step is to choose a topic. Here are some suggestions to get you started: Names of Predator Butterflies, Foods for Thinking Zombies, or Modes of Miniature Transportation. Now you have something to create your list from. Now, devise ten descriptive names that will fit the bill, and pick one to start your adventure into drawing fantastical things. "For those who need to break free from the same types of imagery, this is an exercise that will have you drawing new and bizarre concepts quickly for a change of pace," Zollars notes.

Finding it too hard to develop a list on your own? Consider collaborating with a friend, where one person writes the noun (butterflies, zombies, transportation, etc.) and the other writes the descriptive word (predator, thinking, miniature), then you both can choose a premise like Names of, Foods for, or Modes of to develop the topic. Or use one of these seven topics to prime your creative pump:

TOPICS

Foods for Thinking Zombies

Modes of Miniature Transportation

Games for Your Guinea Pig's Fifth Birthday Party

Names of Elephant Eyewear

List of Drinks for Dragons

Houses Styles for Comics Villains

Dinosaurs You'd Most Like to Invite to Tea

TIP *A dictionary can expose you to unique and unfamiliar words. Just randomly open one at any point and search the page for word prompts.*

NAMES OF PREDATOR BUTTERFLIES

1. THE TIGER LADY
2. THE HARVARD PROFESSOR
3. BEAST OF BOTSWANA
4. IMELDA THE WILD
5. BELARUS BATTLESWAN
6. BON BON BETSY BIRD
7. MELANINE MONSTER EYE
8. TETTRAZINI'S TERRIBLE TANGO
9. FLUTTERBIE'S FRISBEE
10. FLYING PIRANHA
11. PERCIVIOUS INTRUDUS MAXIMUS
12. BALLANTINE BULLET

Names of Predator Butterflies

1. The Tiger Lady
2. The Harvard Professor
3. Beast of Botswana
4. Imelda the Wild
5. Belarus Battleswan
6. Bon Bon Betsy Bird
7. Melanine Monster Eye
8. Tettrazini's Terrible Tango
9. Flutterbie's Frisbee
10. Flying Piranha
11. Percivious Intrudus Maximus
12. Ballantine Bullet

JAIME ZOLLARS

01 A page of sketches where Zollars works out ideas
from her Predator Butterfly list **[a]**, and a detail list
for Names of Predator Butterflies **[b]** that exposes
her interests in history, the Far East, and alliteration.

40. EVERYDAY LISTS

Many of the exercises earlier in the book are based on Surrealist games that directly and indirectly influenced image making in the twentieth century. The Surrealist movement was about visual art as well as word art in poetry and literature, and words are great departure points for instigating ideas. So it makes sense that we look at a variety of ways to have words—or text—influence the creative process.

We are surrounded by lists. Grocery lists, to-do lists, lists of favorites, lists of names, lists to inventory things in a box or a room, lists of characteristics, lists of countries, lists of random or seemingly disconnected items. Some are written carefully, like a list you give to someone going to buy groceries—you want them to get it right!—and some are carelessly scrawled in the corner of a page, because you know that fleeting thought will certainly be forgotten. Then there are used lists that have been crossed out, or lists that remain as yet unused, written in pen or pencil, in color or pure black ink. Any of these can create a unique visual—an interplay of marks on a page. The handwritten list cloaks each word in personality, while the typewritten list gives an air of detachment and formality. Lists can also become the starting-off point for drawing to respond to or replicate the written words—to literally draw an image of each word.

This exercise is twofold. First, it gives permission to think of writing as drawing and to appreciate the texture of the marks. It also welcomes accidents, and sees the paper as an artifact, an object made over time.

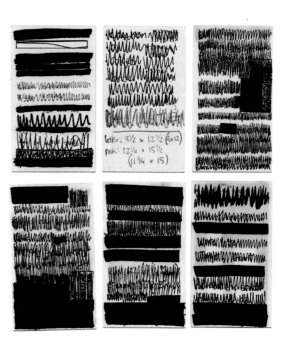

PAUL RYAN

01 Painter Paul Ryan is an obsessive list maker, and a bit of a conservationist, who has turned the back of old business cards into to-do lists. Once the "to do" is done, it is densely marked off the list. He saves the cards in stacks in a drawer, and uses them to make small collage arrangements.

01

04/a

04/b

04/c

02

03

ANONYMOUS

02 This page from an organizer offers interesting and textural visuals that feel strangely familiar. They record time through the type of pen used and simultaneously defy it through notations that don't stay inside their individual date boxes!

GUIDO SCARABOTTOLO

03 At the Office by Guido Scarabottolo, an editorial illustration commissioned by New York Times art director Alexandra Zsigmond, accompanied a review of a short novel. The image portrays mundane things around us. By recording them, we begin to make associations or see aspects of each item we may have previously overlooked.

NA KIM

04 Brooklyn illustrator Na Kim has an eye for everyday things, and the evidence of the user on them. Her images of butter [a], lawn chairs [b], and matches [c] each use a specimen-style approach to talk about the objects and their function.

ALEX CITRIN

05 Alex Citrin rendered her possessions in a very matter-of-fact manner, counting off the activities and moments in a day.

06

JORGE COLOMBO

06 Jorge Colombo took a moment to capture the packaging of the beer and the bag it came home in, being selective about where he used color.

DINGDING HU

07 In the first sketch, Dingding Hu, one of my graduate students from China, drew her apartment room, labeling the parts of it [a]. You can see notations in both Chinese and English that serve as a reminder of words she was still learning. The other sketch of contrasting rooms cleverly uses the gutter of the sketchbook [b] to imply a break from one room to another, hinging the door to the shadow between the pages. The contents of each room are editorialized through not only our understanding of status between bunk beds and more adult beds, but also through the highlight sparkles applied.

NA KIM

08 Na Kim also writes messages within her drawings of everyday things that give us clues to the relationships and to Kim herself. Moments like giving up smoking [a], finding salvation in a hairpin (*lifesaver*) [b], learning how to be cool from a library book (*how to be fly and stay fly*) [c], or chronicling an encounter through a phone number written on a napkin and ice cream sandwich (*Pierre, oh Pierre! Stop it.*) [d]. Each sends coded messages and double meanings. Is Pierre cool or merely flirtatious?

KELLY LASSERRE

09 Kelly Lasserre's hand-painted bags started with the first bag she made as a gift for her sister. Lasserre decided to list all the things she had found in her sister's older tote. From there she received several requests to make others, each giving a portrait of the owner through the everyday.

MARTIN HAAKE

10 With the exception of a few items, Martin Haake's food illustration makes a visually diverse representation of foodstuffs that virtually every culture can grasp, and at the same time documents unique characteristics through his choices of shape and color.

05

replaced by bad habits.

08/a

LIFESAVER.

08/b

Pierre. Oh Pierre! Stop it.

08/d

08/c

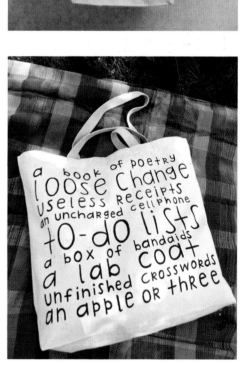

story books
tissues
sermon notes
fruit snacks
crayons
extra juice cup
loose change
notebook with doodles
water bottle

a book of poetry
loose change
useless receipts
an uncharged cellphone
to-do lists
a box of bandaids
a lab coat
unfinished crosswords
an apple or three

09

10

41. DREAM RÉSUMÉ

The dream résumé takes the form of an employment résumé, but is different because it is our fantasy chronicle of our achievements. Sometimes dream résumés contain the achievements of both. It is your choice to include or exclude information: It is your dream! To start, think about what a well-designed résumé looks like. There is a visual hierarchy where we can see the different aspects of the person—her education, her skills, where she lives, how to get in touch with her, and sometimes even hobbies or activities outside the sphere of work. Now translate that premise into a dream scenario. The subject is you, but where you have spent your days (working), where you live, how we can contact you, and so on are all open to fantastical (or ordinary) interpretation. Using compartments or groupings can give the fantastical a sense of order. Think about it: If your employment résumé did have the order and structure of sentences and paragraphs, it would be very hard to read.

01/a

STELLA BJÖRG & MARTIN HAAKE

01 These examples of work by Stella Björg and Martin Haake were not created as dream résumés, yet they have all the elements of visual order to suggest a dream narrative presented as a résumé. Observe Björg's flat graphic style that organizes iconographically rendered objects into a header **[a]**, while Haake takes advantage of collage and found paper to structure his page **[b]**.

42. **SKETCH SHARE**

Collaborating on a sketchbook

can come in many forms—all you need is to have an agreed-upon direction for your collaboration and you'll be set. As an example, the Sketchbook Project is an exciting project run by Art House, a Brooklyn-based company that organizes global collaborative art projects. The Sketchbook Project, with more than 26,000 books, is an annual invitation to add to the collection. Art House also runs the Brooklyn Art Library, a storefront exhibition space in the Williamsburg section of Brooklyn. As their website notes, "Art House nurtures community-supported art projects that harness the power of the virtual world to share inspiration in the real world. All of our projects are open to everyone." For a small fee, you can register for a sketchbook that you receive and return to their library once completed. The sketchbooks are available to view at their library, and Art House curates traveling exhibitions. Their digital library allows viewers around the world to look through journals that have been submitted. Recently, I engaged my first-year graduate students in the Sketchbook Project as part of their fall term assignments. Each book had a topic, as follows: Travelogue, Memoir, Atlas, Chronicle, Chapbook, Documentation, Dwellings, Strangers, Diagrams, Lists, Creatures, Dinosaurs, and Mystery. Each themed book was assigned to a specific student with instructions to trade sketchbooks each week. By staying on theme, yet changing the artist, the students were challenged to do increasingly better work.

01

02

04

03

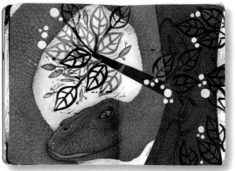

05

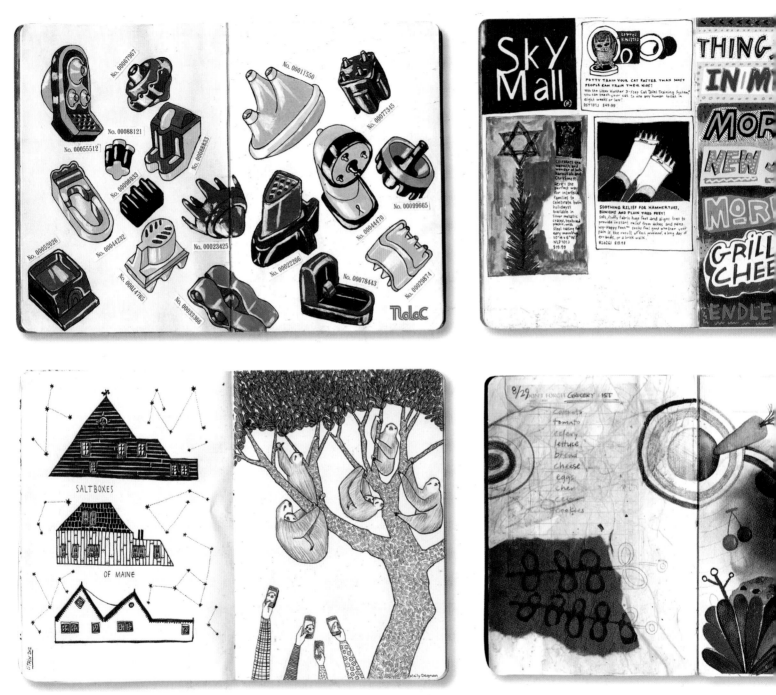

06

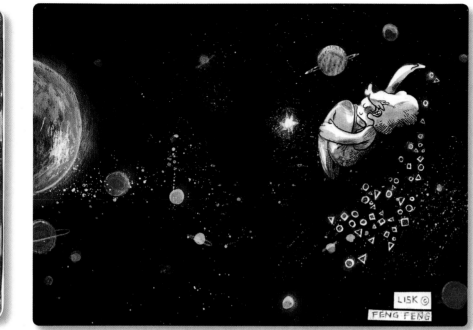

07

08

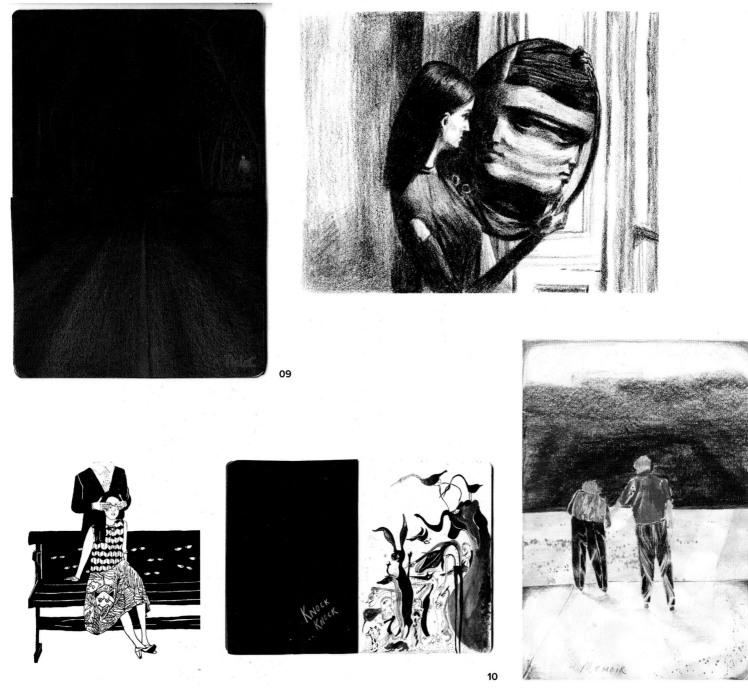

09

10

11

EDUARDO CORRAL & DIYOU WU

09 *Mystery*

DIYOU WU & SARAH JACOBY

10 *Strangers*

SARAH JACOBY

11 *Memoir*

JOAN X. VÁZQUEZ

12 Mexican artist Joan X. Vázquez is an illustrator and graphic designer, and was a co-owner of Amarillo design centre in Veracruz, Mexico, a design store, gallery, workshop, and studio concept created to promote and elevate design. He likes to participate in projects with social and historical content and as such has found participating in the Sketchbook Project rewarding. Through the digital library, people from around the world can see his work online and in person at the Brooklyn Art Library.

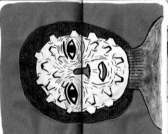

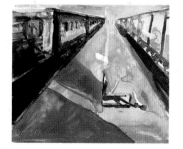

12

43. **COLLABORATIVE SKETCHBOOK**

This exercise is to develop a collaborative sketchbook idea of your own. Start with a topic of interest, and then develop a premise for causing the collaboration. It could be a public location (your favorite coffee shop, Laundromat, or dog park), it could be friend to friend to friend like a "six degrees of separation" idea, or it could be at your home or studio and people are invited in to collaborate. Once you have a topic and premise, you can activate your collaboration. Remember to document the work (videotape sessions, or scan the page spreads). Be sure to make the premise manageable, so you can follow through with the idea.

In the year 2000, a San Francisco artist named "someguy" launched his first 100 collaborative sketchbooks into the world by leaving them at bars, cafes, and public park benches for someone to find, draw in, and pass along to another. Also known as artist and designer Brian Singer, someguy made each sketchbook cover visually exciting, with instructions incorporated into the artwork to help anyone who found the sketchbook understand the concept of the project: find it, draw in it, pass it along. Each sketchbook clearly stated that "this is an experiment and you are part of it" on the cover. When completed, the last person was to send the book back. Singer identifies the projects as a "shared artifact network connecting strangers the world over." He says, "The rhetoric about what's good or bad for the economy led to my questioning why we're not talking about what's good or bad for people instead. I seek to make people think, consider, and even question their preconceived beliefs."

The concept became so popular that the first 100 turned into the 1000 Journals Project, with Singer offering the cover designs to artist friends to create. He set up a website to track each journal, asking for the collaborators to post page spread scans and allow others interested in collaborating to sign up to receive a journal. You can look at the vast catalog of interior pages at www.1000journals.com/journals and the cover designs at www.1000journals.com/covers.

The journals have also become the subject of a published book, exhibitions, and a documentary film. Singer has taken the idea of these sketchbooks to a new level in his 1001 Journals Project, where you learn how to activate your own collaborative journal project (see www.1001journals.com/about/faqs) or join in the collaboration of a C* Journal created specifically for individual's experiences with cancer.

01

02

MARK T. SMITH

01 Sketchbook cover

MICHAEL BARTALOS

02 Sketchbook cover

44. USED BOOK SKETCHBOOK

British illustrator and educator

Rebecca Bradley uses old books from book-stores as the basis for an assignment she gives her students. She purchases and distributes old books found locally at The Book Thing, a nonprofit organization established to circulate books. The Book Thing takes in used book donations and resells them at a reasonable cost. Bradley feels keeping this sort of sketchbook helps create fresh ideas and fosters new and unexpected images. "The books (from The Book Thing) are generally suitable for working in since they have thickish paper, room for imagery, and not too many pages. Children's picture books work well," notes Bradley. The criteria for working in the used book are simple—combine a new drawing with existing text and images, or mostly obliterate existing text and imagery, making the new image dominant. Either way, the "white" of the page is already broken, and the fear of the page is gone.

One way to assign this project is to give the found book a theme, and let the contributor respond to the theme as well as the imagery and type that already exist on the printed page. Or assign criteria such as color restrictions, and have the books circulate. Each variation can bring new inspiration. Bradley has used the following sketchbook concept directions with success:

Thematic Sketchbook: Each contributor addresses the same single theme regardless of what is printed on the book pages.

Reworked Sketchbook: The contributor responds to a theme and to the existing elements on the page.

Hero Sketchbook: After describing a "hero," the contributor describes what the hero looks like, what he or she is looking for, and so on. Each week the contributor adds more to the story.

Concept Sketchbook: Using a number of supplied words such as "elaborate," "shrink," and "multiply," the contributor responds by using conceptual thinking.

Yin-Yang Sketchbook: With sketchbooks changing hands each week, each contributor responds to the prior week's entry with an opposite image and has to make a reference to the prior entry through palette, character, story line, composition, mark making, or horizon line.

Given-Story Sketchbook: Individual lines of a passage or poem are attached to each page in succession, with the contributors responding to their one line before passing the sketchbook to the next contributor. At the end the story unfolds, told by many voices.

01

ALISSANDRA SEELAUS

01 *Octopus Emotions*

AMANDA YONKERS

02 *Just Enough Intelligence*

MARISSA LANTERMAN

03 *Fault Line*

04 *Devil's Run*

02

One has been endowed with just enough intelligence to be able to see clearly how inadequate that intelligence is when confronted with what exists.

— Albert Einstein.

SHERRY BOSLEY **Fault Line**

I didn't consider
dumb loyalty returning
taking my thoughts away
like the others who
packed without folding

HAHAHAHAHA! I AM SO MUCH TALLER THAN YOU!

Amusing

03

Devil's Run

Locking the door behind him, he pauses at his **Aviary**, and bids farewell to his precious birds

04

05

07

06

Purchasing a used book to keep as a sketchbook is a great way to break the page and challenge you to work with what is found on each page, but you can go one step further and create your own used-book sketchbook.

MATERIALS

Large book, ideally 10- to 12-inches (25 to 30.5 cm)-wide pages

Paper cutter

Tablespoon or bone folder

Binder clips

Thread

Sewing machine

Sewing needle

Heavy-weight paper (optional)

Small dish or saucer

PVA glue

1 ½ to 2-inches (3.8 to 5 cm) brush

STEPS

1 Remove pages from the large book.

2 Collect pages in stacks of six sheets and fold in half.

3 Make sure the edges of the pages match up evenly.

4 Use the large spoon or bone folder to burnish the pages down.

5 Reopen the pages and ensure they are aligned.

6 Place a clip at the left edge, top and bottom, of the page stack.

7 Decide on a matching or contrasting thread for the sewing machine.

8 Set the stitch to a medium length and sew along the crease made when the pages were folded.

9 Remove the binder clips and refold the pages along the stitching. Use the spoon or bone folder to reburnish the page sets. With six pages folded, you now have a twelve-page signature.

10 Make as many of these signatures as you prefer. Use the binder clips to clip the signatures together. Use needle and thread to stitch the signatures together at the top, bottom, and middle.

11 A cover can be added if desired by cutting a piece of heavy-weight paper the height of the existing cover and width of the front and back covers, plus the thickness of all the pages added together. Using the bone folder, score the cover sheet at the spot where the front cover meets the spine and again where the back cover meets the spine. Refold the cover in the opposite direction so the sheet lies flat. In a separate small dish, make the viscosity of the glue similar to that of lotion. Brush the glue on the inside of the cover using the wide brush. Match one vertical side of the cover to a vertical side of the book and carefully fold the cover around the book pages.

45. ALPHABET-A-WEEK SKETCHBOOK

After teaching illustrators and designers for more than fifteen years, I noticed that many are not immediately comfortable with hand-drawn letterforms. In a course I developed called Handletter, I strove to break the stigma these students placed on letters. For this exercise, keep a separate sketchbook and add one full alphabet to it each week of hand-drawn letterforms. The letterforms should begin with inspiration from a shape or texture worked out as a letterform. Carry that shape, image, or texture through to each letter. The alphabets should not be fully rendered; rather, they should be rough sketches to keep your attention on working the premise throughout each letter. Some letters will not be successful, but that's okay. You can finalize or refine them later. The goal is to complete the alphabet no matter what. This exercise creates an incredible archive of ideas and lettering to draw on at a later time.

MATERIALS

Wire-bound sketchbook approximately 8 x 10 inches (20 x 25 cm)

Tracing paper

Pencil

Sharpener

Eraser

Pen such as a crow quill, rollerball, fine-tipped, or brush-tip marker

Small steel ruler

Tape (any kind)

Glue stick

Scissors

Approximately ⅝ inch (1.6 cm) #8 round-tip brush for water-based media

India ink, black tempera, or other black liquid paint

9 x 12 inches (23 x 30.5 cm) pad of layout paper, stack of copier paper, or small sketchbook

Digital camera (regular or cell camera)

STEPS

1 Using a variety of the materials and media, relate letterforms to the objects around you. Looking at a chair from the side, one can see how much it looks like a lowercase "h," or lay a sweater out flat with the arms extended and you can see the uppercase letter "T." Once you consider this concept, it's hard not to see letters everywhere!

2 Create an ongoing library of chance meetings with letterforms in the world. Use your cell phone or an inexpensive camera that you can easily have on your person at all times to capture these fleeting moments.

3 Use a portable sketchbook to develop an alphabet a week. This will take a commitment to keeping that up as well as allowing yourself to only complete an alphabet if it is not forced. Fun is a very important aspect of learning. Start with a single letter that you have seen or photographed, or an idea or object, and build outward from there. If doing the alphabet in order is daunting, do it out of order. Just find ways to overcome any reluctance to making letters.

01

02

01 Nicole Mueller

02 Stacey Dugan Montebello

03 Kim Gim

03

04

05

04 Eve Mobley

05 Steven Johnson

06 Alex Lasher

07 Nora Truskey

06

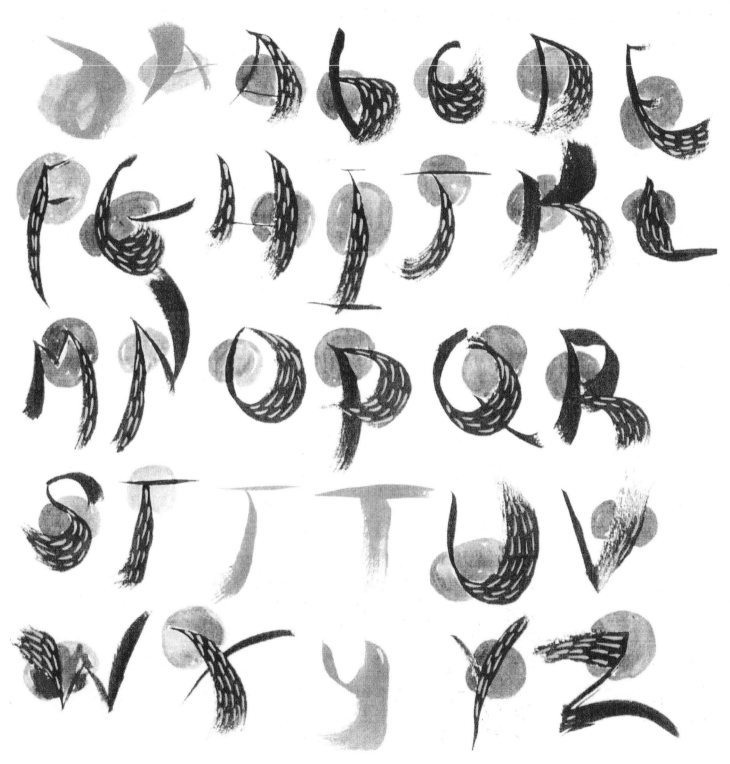

UNDERSTANDING LETTERFORMS

It's important to understand hand lettering is not the same as typography, but it does help to understand basic principles of letterforms before you begin to draw them. We have all grown up looking at and writing letterforms, and we have an informal mastery of them as a result. This can work in your favor to not be trained—to come to letterforms from a naive perspective. It can also be helpful to have purposefully looked at letterforms. There are many great books on typography; these are some of the ones I recommend students use to familiarize themselves with letterforms and see them used by a wide variety of makers.

Bantjes, Marian. *I Wonder*. New York: The Monacelli Press, 2010.

Benerra, Neal, and Kerry Brougher. *Ed Ruscha*. Washington, DC: Smithsonian Institute, 2000.

Berry, John D. U&lc: *Influencing Design & Typography*. Brooklyn, NY: Mark Batty Publisher, 2005.

Blackwell, Lewis, and Lorraine Wild. *Edward Fella: Letters on America*. New York: Princeton Architectural Press, 2000.

Emmerling, Leonhard. *Basquiat*. Los Angeles: Taschen, 2003.

Friedl, Friedrich, Nicolaus Ott, and Bernard Stern. *Typography*. New York: Black Dog & Leventhal, 1998.

Gastman, Roger, and Jim Houser. *Babel: Jim Houser*. Corte Madera, CA: Ginko Press and R77, 2005.

Grushkin, Paul. *The Art of Rock Posters from Presley to Punk*. New York: Abbeville Press, 1987.

Heller, Steven, and Mirko Ilic. *Handwritten*. New York: Thames & Hudson, Inc., 2004.

Laskey, Julie. *Some People Can't Surf: The Graphic Design of Art Chantry*. San Francisco: Chronicle Books, 2001.

Lupton, Ellen. *Thinking with Type*. New York: Princeton Architectural Press, 2004.

Matisse, Henri. *Jazz*. New York: George Braziller, Inc., 1985.

Matthias, Arnold. *Henri de Toulouse-Latrec, 1864–1901: The Theatre of Life*. Cologne, Germany: Taschen, 2000.

McMullan, James. *The Theater Posters of James McMullan*. New York: Penguin Putnam, Inc., 1998.

Perry, Michael. *Hand Job: A Catalog of Type*. New York: Princeton Architectural Press, 2007.

Rothenstein, Julian, and Mel Gooding. *More Alphabets and Other Signs*. San Francisco: Chronicle Books, 2003.

Ruscha, Edward. *They Called Her Styrene*. New York: Phaidon Press, 2000.

Spender, Stephen, ed. *Hockney's Alphabet: Drawings by David Hockney*. New York: Random House, 1991.

46. NATURE'S ALPHABET

One of the most popular exercises I've developed for illustrators who are interested in letterforms is the Nature's Alphabet exercise, likely due to the fact that it allows them to explore letterforms, legibility, drawing, and assemblage. It's very freeing and lends itself to organic shapes that illustrators are most comfortable with. The rule for this exercise is that the subject materials need to be found in nature—nothing man-made.

LUCI EVERETT

01 Australian artist Luci Everett crafted this mixed-media alphabet *Alfalfabet* for the fashion blog *Frankie Magazine* using collage scraps and various natural elements. She uses cut paper, painting, and scanning to achieve her results.

STEVEN JOHNSON

02 Another former student, Steven Johnson, smartly used a few bananas to make the letters, photographing them as he went, then assembling the entire alphabet in Adobe Photoshop. To students, food is a precious commodity, so these were all eaten after his project was completed.

02

STELLA BJÖRG

03 Icelandic designer and illustrator Stella Björg originally studied English, letting her love of books, and in particular literature, be her guide. She then went on to study graphic design and ultimately began working in design and illustration. She lives in Reykjavik, but regularly goes to her haven Ugluholt (Owl Hill), which was the inspiration for these letterforms. Björg's precise crafting makes each letter its own tiny universe. They are meticulously drawn in pen and ink, and colored in watercolors. The entire collection can be found at http://stellabjorg.com/50196/549618/gallery/ugluholt-an-alphabet-book.

04 Specimen sheet detail

05 Letter H

06 Letter B

07 Letter S

01

04

05

06

07

03

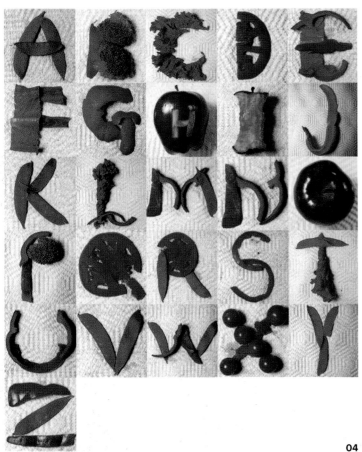

04

TIP *Consider how the tool you use influences the finished drawing and the effectiveness of the visual.*

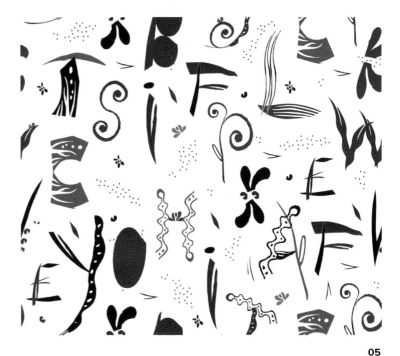

05

06

ALEX LASHER

04 Alex Lasher, a former student in my MICA HandLetters class, used fruits and vegetables to make this beautiful composition—some shapes coming naturally, some crafted by cutting, trimming, and slicing. I love his bold "O," a whole apple and the paper towel background.

WHITNEY SHERMAN

05 *AlphaBits* is a repeatable pattern I created to post on the online fabric shop Spoonflower.com. I took foliage details from one of my commissioned illustrations (see the Image Harvesting exercise). Next, I assembled the letters using the parts I had, and then I converted them into Adobe Illustrator files that I could color and place into a repeatable pattern (see the How to Make a Pattern exercise).

06 *Alain* is a sketch I made during a trip to Josselin Castle, the fifteenth-century former residence of Alain de Rohan VIII in Brittany, France, on the River Oust. The forms I sketched were carved over the château fireplace, reflecting the unique visual sensibilities of the Bretons, a Celtic subset, where Welsh and Celtic legends of King Arthur, Tristan and Isolde, Korrigans (female fairies), and Merlin solidified.

JUAN CARLOS VÁZQUEZ PADILLA

07 Juan Carlos Vázquez Padilla's version of Hair letterforms is formed on a photocopier using real human hair [a]. As this image shows, he had to work with the natural curves of the material [b].

07/b

07/a

47. **SKETCHING COVERS**

This exercise is about looking at everyday objects that use letterforms, such as book covers, magazine covers, or packaging, and distilling them down to simple drawings. Because book and magazine covers contain a combination of image and text, this exercise gives you an almost unlimited selection of shapes and contrasts. Book and magazine covers are designed with strong compositional elements that form a solid platform on which to be expressive.

01/a

01/b

02/a

02/b

NA KIM

01 While you may choose to relax some of the typographic structures when making your covers to bring a certain accuracy to your drawing, you may also use humor to rewrite titles, as Brooklyn illustrator Na Kim did on her covers to two very well-known books: *The Catcher in My Thighs* [a] and *Wuthering Tights* [b]. Both titles draw us in, yet transport us to another conversation, a singular conversation on sexuality from a female point of view that is simultaneously direct and indirect.

ALEX CITRIN & MIKKEL SOMMER

02 With magazines being as pervasive as books, illustrators Alex Citrin and Mikkel Sommer both took on popular magazines, focusing on their cover content in different ways. Citrin's drawing is a replication of the *New York Magazine* cover [a], offering headlines from real stories like "And the (Mayor's) Race Is On: Early Handicapping of the Post-Bloomberg Era." Mikkel Sommer took an entirely different tack, creating a parody of a typical *Cosmo* cover [b], rewriting the usual sensational or banal headlines and subheadlines, such as "Fashion tips, 117 ways to wear pants and shorts, or something like that" or "Why monkeys age so well" or "12 ways to look slutty (in a good way)."

48. SKETCHING FROM THE MASTERS

Sketching from the masters is a classic and time-honored practice that can help you see how master artists developed their ideas and, in the process, cause you to study their thinking process. How did they choose to represent things, what is suggested, what is articulated? The masters, as they are called, abided by the rigors of study, practice, more practice, and a protocol of setting up a workshop with apprentices who followed the "ways" of their master. The traditions of the masters remain today, but you have the ability to select from works outside this definition to find your own "master(s)" to study and sketch. This exercise is not just about using your eye; it's also about your thinking, because ideas are the starting point for your final design.

The term *old masters* is generally agreed to mean works by artists practicing prior to 1800, yet as time goes on, this framework has by necessity needed to be relaxed in the world of academia. Being considered an old master required certain training and competency, but never a guarantee of quality. You can engage with visual art of all kinds, not just the pieces labeled as coming from the old masters.

Going to the museum, rather than drawing from reproductions, is the most desirable method for sketching from the masters. On location, you have the ability to assess the surface of original works. And many museums hold sketching classes in their galleries that assist beginning sketchers with their observations. Some simple commonsense guidelines to follow are: choose works that you love, wear comfortable clothes, work at a portable size, and find locations where you might not be disturbed until you gain your sea legs. It is also extremely important to check with the museum you visit beforehand to learn their sketching rule. Rules vary from museum to museum on materials and sketching hours allowed.

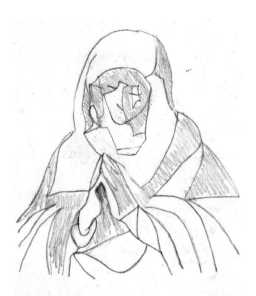

Museo Nazionale Romano

Roman heads
2nd century AD

02/b

Bernini angel
Ponte Sant'Angelo
sunny morning
after snow

02/a

Great Hall
Museum of Anthropology

University of British Columbia

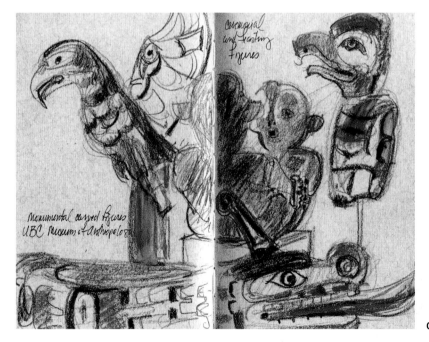

Ceremonial
and Feasting
Figures

Monumental carved figures
UBC Museum of Anthropology

02/c

MARGARET RAMSAY

01 British conservation biotechnologist Margaret Ramsay creates art textiles inspired by the natural world and is currently exploring ways of interpreting sketches directly onto fabric. An amateur artist, she posted her studies of master paintings on her blog, magsramsay.blogspot.co.uk, along with imagery of other works she has looked at in pursuit of improving her "thinking." On her blog posts she is analytical and documents her area of focus, whether it is tone, form, composition, or another concern, as well as auxiliary images in the same area. She sketches mostly in the National Gallery and many times works on images not for their subject matter but for the challenges they bring. Here are the thumbnail and sketch study of the painting *Virgin in Prayer* by Sassoferrato (Giovanni Battista Salvi) [a] and the thumbnail and sketch study of the painting *The Miraculous Draught of Fishes* by Peter Paul Rubens [b], both done at the National Gallery in London.

LAURA MURPHY FRANKSTONE

02 Laura Murphy Frankstone is an artist who travels the world sketching what she sees. Her Typepad site, called lauralines, is loaded with her work, including travel sketches that range from the Lake Myvatn area of Iceland to the Dordogne region of southwestern France to the Berlin Zoo. Of interest for this section of the book are her travel sketches from Rome, where she was able to sketch classic forms in sculpture, such as Bernini's *Angel* [a], *Ponte Sant'Angelo*, and *Roman Heads* [b], second century CE, at the National Museum of Rome. She has also captured indigenous woodcarvings of totem figures and sketches of the Great Hall at the University of British Columbia's Museum of Anthropology in Vancouver [c].

ROZ STENDAHL

03 Roz Stendahl is a graphic designer, an illustrator, and a writer. Along with visual journals and classes she teaches on book arts, she also continues her process of "looking" by making sketches from sketches by John Singer Sargent.

JANE HEINRICHS

04 Illustrator Jane Heinrichs spends a lot of time in galleries sketching from the old masters. "Walking around the darkened rotunda of the 'reading room,' looking at the delicate coal and sepia sketches by the Italian masters (Fra Angelico, Leonardo, Michelangelo, Raphael) filled me with renewed inspiration and vigor for my field." Taking a lesson from Leonardo da Vinci, Heinrichs made a note of one of his quotations on her sketch to remind herself to loosen up—one of the benefits of sketching in a museum [a]. Her sketches included here are from the Italian Renaissance Drawings exhibit, British Museum, London, and of left hands found at the National Gallery, London [b]. So inspired by museums, Heinrichs wrote and illustrated a book titled *Magic at the Museum*, a story of a little girl on her birthday that features works from the permanent collection of the Courtauld Gallery in London.

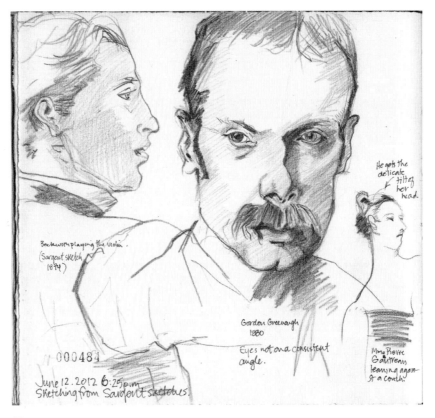

03

04/a

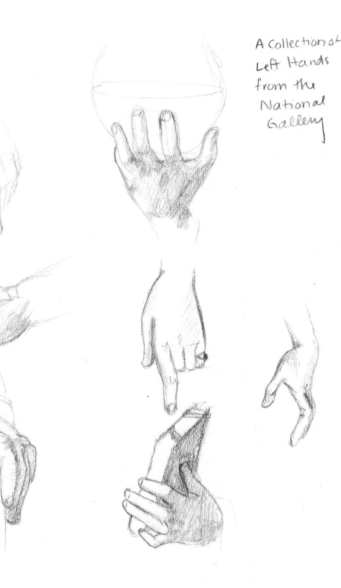

A Collection of Left Hands from the National Gallery

gloved hand + book

04/b

BOOKS ON DRAWING FROM THE MASTERS

Time, schedules, or your location can prevent direct access to museums. To remedy that, consider using a catalog or book collection of high-quality print reproductions. Here are a few recommendations for instructive and affordable books on drawing from the masters.

Hale, Robert Beverly. *Drawing Lessons from the Great Masters: 100 Great Drawings Analyzed, Figure Drawing Fundamentals Defined*. New York: Watson-Guptill, 1966 (first edition). This 271-page hardcover book is illustrated with numerous plates. The author was the former curator of American Paintings and Sculpture at the Metropolitan Museum of Art, a teacher at the New York Student's Art League for forty years, and adjunct professor of drawing and lecturer on anatomy at Columbia University. Hale also coauthored *Anatomy Lessons from the Great Masters*.

Malins, Frederick. *Drawing Ideas of the Masters: Improve Your Drawings by Studying the Masters*. New York: H. P. Books, 1981 (first edition).

Toney, Anthony. *150 Masterpieces of Drawing*. Mineola, NY: Dover Publications, 1963 (first edition). This 150-page softcover book has full-page drawing reproductions from the early fifteenth century through the end of the eighteenth century, including numerous master artist reproductions.

KATHERINE TYRRELL

Artist and writer Katherine Tyrrell is a true advocate of sketching. She draws and writes about art for artists and art lovers. Her blog, MakingAMark.blogspot.com, is number three in the top twenty-five art blogs in the UK, with 4,300+ subscribers. On it she has numerous tutorials and postings where she shares her techniques and adventures in sketching. It's a vast universe of information that gives recommendations from tools to use, to locations, to her 10 "do's and don'ts" for how to draw people while eating (July 14, 2009). Just keep digging and you'll find her personable and generous nature to be contagious. In the fall of 2009, she made a posting titled "28th September: 10 art museums in Paris" that is a wealth of information to get you started on sketching in those museums (http://travelsketch. blogspot.com/2009/09/28th-september-10-top-art-museums-in.html). In addition, she has posted "Top 10 Art Galleries and Museums" and "Top Ten Museums in London" on the site Squidoo.

Give yourself time to look through her sketchbooks. They are all wonderful, yet I was particularly delighted when I noticed that her museum sketching led her to the museum café, where she picked up her sketching and captured people eating. Museum cafés are one of my guilty pleasures (along with the bookstores) when I go to a museum! Follow Tyrrell's lead on sketching and you can't go wrong.

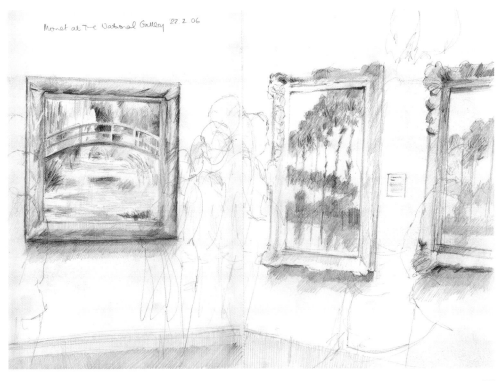

05

05 *Sketching Monet*, National Portrait Gallery, London. Tyrrell solves the problem of a crowded gallery by working on three separate paintings in the room at one time and incorporating the "ghosts" of the gallery-goers into the environment.

06 Sketch of *Antibes* by Claude Monet, Courtauld Gallery, London.

07 Sketch of *Boat-Building near Flatford Mill* by John Constable, Victoria & Albert Museum, London. Be sure to visit the Constable sketchbooks when at the V&A.

08 Sketch of visitors to British Petroleum Portrait Exhibition, 2011, National Portrait Gallery, London.

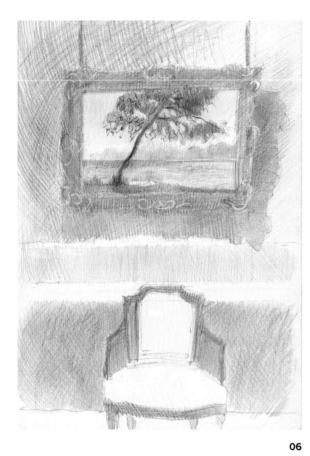

06

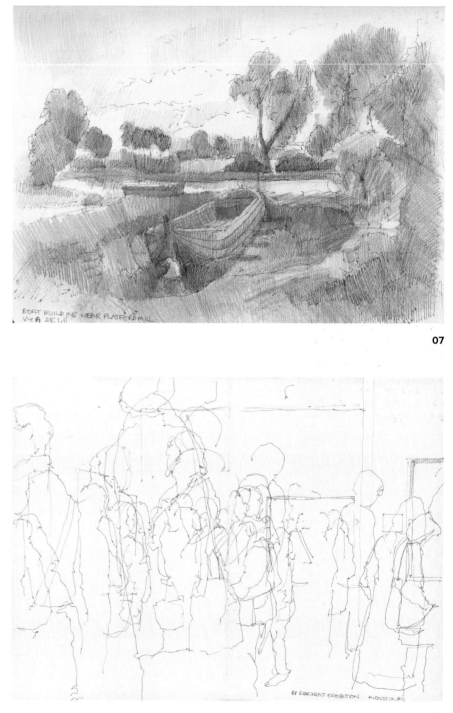

BOAT BUILDING NEAR FLATFORD MILL
V & A 28.1.11

07

BP PORTRAIT EXHIBITION AUGUST 2011

08

49. SKETCHING FROM FILM

Designer Debbie Millman is known for many things, but one of her "guilty pleasures" is sketching from films—freeze-frame as well as on the fly. Her first encounter with this idea began while at home watching the film *Beginners* on On Demand. In the film, the main character, played by Ewan McGregor, is a graphic designer and an illustrator. Millman became so inspired by the story and the main character that she grabbed a blank Moleskine notebook and began drawing along with the movie. "I did it live, in real time, no erasing or editing, and I didn't stop until the movie was over," she notes. By happy accident, she finished the notebook as the film ended. She has, to date, sketched out four films, including *Beginners, The Descendants, We Need to Talk About Kevin*, and most recently, *Melancholia*.

Although Millman's first sketching-from-film project was not planned, the project yielded a few rules of engagement:

1 Feel inspired to interpret a film through drawing. This means you will be invested and curious.

2 Be willing to proceed forward and not plan how the line, composition, or imagery will end up looking. This is drawing with abandon that ultimately leads to discovery.

3 Start with whatever tool is convenient, and work through any issues that tool might bring on. Embrace the mistakes.

4 Find meaningful elements to record, large or small.

5 Remember: words and letters are pictures, too!

6 Set your rules, but know you may have to break them.

Millman's original sketching-from-film project came all in one push, but she found difficulty doing that with her second project, drawing from *The Descendants*. She had to stop the video when there was fast dialogue or complex hospital scenes. Had she stuck to her "live, real time, without erasing, editing, or stopping" criteria, she likely would have missed drawing certain key scenes. Instead, Millman adapted her criteria to the situation. She did the same, only slower and with freeze-frames. Her third project, illustrating *We Need to Talk About Kevin*, took on another approach. Deeply interested in the film that she anticipated would be disturbing, Millman decided to pre-watch it, then watch it to make the drawings. The first viewing had such a profound and disturbing effect that she felt "the only way to erase them from my imagination might be to get them down on paper."[1] Sketching *Melancholia* also caused her to introduce color, perhaps to show the "remarkable range of human emotions both women experience and the unexpected ways in which they tolerate situations that are out of their control," she explains. Millman has also begun to think about "wrestling outside the confines of the Moleskine." All of this leads to the last rule:

7 Don't make too many rules and things will grow all on their own!

[1] *Debbie Millman, "Watching* We Need to Talk About Kevin,*"*
http://imprint.printmag.com/film2/watching-we-need-to-talk-about-

DEBBIE MILLMAN

01 Millman commissioned videographer Brent Taylor to shoot her "page-turner" videos and had Jacquie Parker turn the pages to a musical soundtrack from the film. These are selected pages from the videos that can be found online at http://imprint. printmag.com/film2/drawing-for-beginners, http:// imprint.printmag.com/debbie-millman/watching-the-descendants, and http://imprint.printmag.com/debbie-millman/watching-melancholia-lars-von-trier.

02 Inspired by the film *Beginners*.

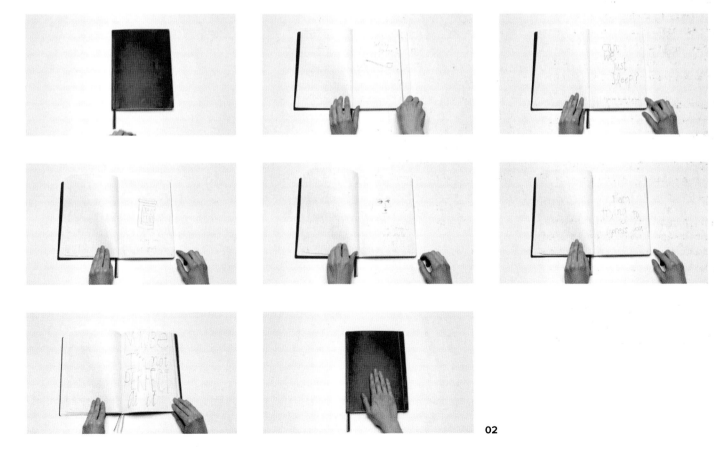

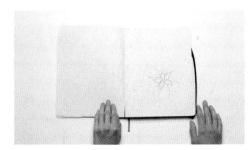

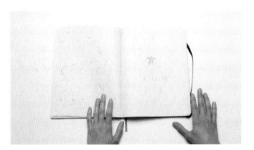

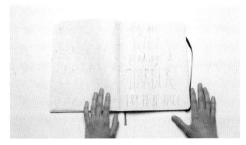

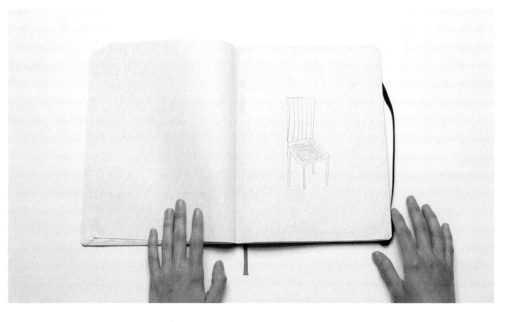

DEBBIE MILLMAN

03 Inspired by the film *The Descendants.*

04 Inspired by the film *We Need to Talk About Kevin.*

03

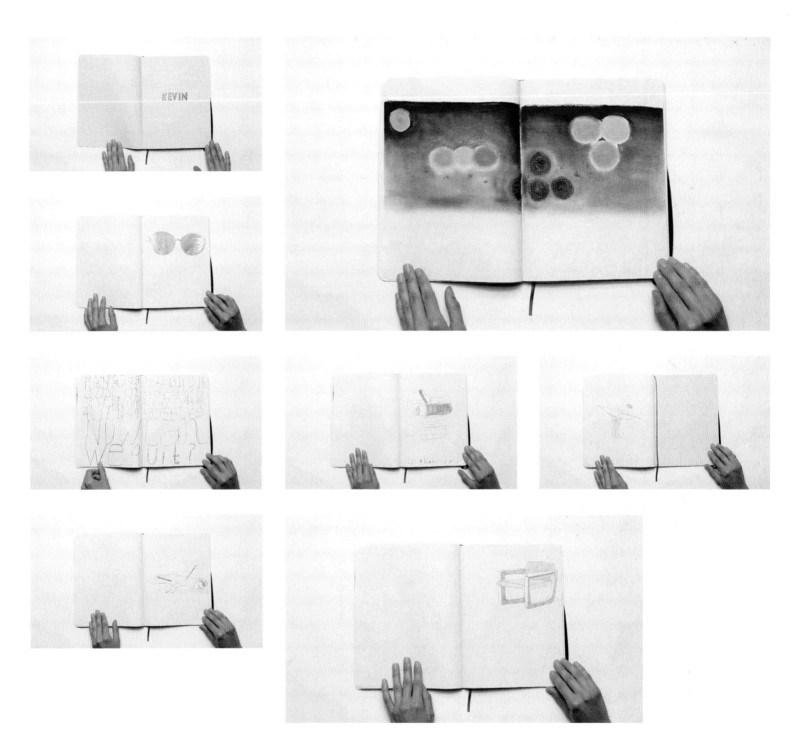

04

50. **GIVING BACK**

Most of the sketching discussed in this book has been for personal enrichment. In this exercise we'll look at artists who have decided that sharing and bringing others together is a good idea. Making your own sketch blog is of course one way to complete this exercise. Here are some variations on that idea.

AMIUNDERGROUND

AmiUnderground is a blogsite collection of sketches from the New York City subway made from the late 1990s to the present, and is a book by the same name by creative director Amitai Plasse, now living in Austin, Texas.

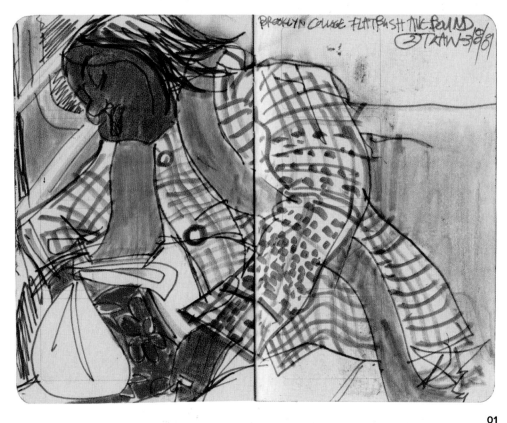

01

AMITAI PLASSE

01 AmiUnderground

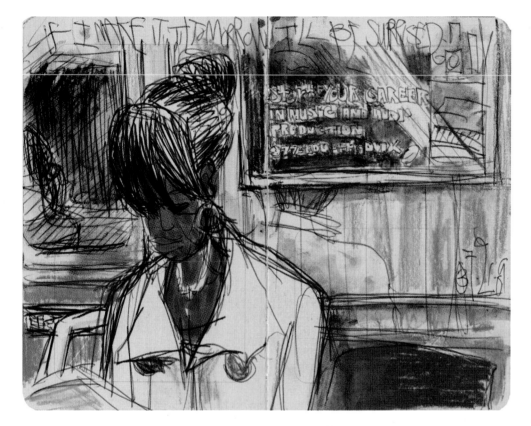

'SKINE.ART

Using the common format, this blog is for sketchers who use a Moleskine sketchbook. They uploaded their work, which is unedited and uncurated, allowing for involvement by individuals with a range of competencies.

Or engage with the sketching community on a social level by joining one of the many existing sketch blogs. Each has its own origin, style, and energy.

SKETCH CRAWL

Sketch Crawl has been called a "drawing marathon around the globe." Enrico Casarosa, a story artist at Pixar Animation Studios, came up with the idea for this after doing a bachelor party pub crawl in the early 2000s. His idea was to do a day of intense drawing around the city, to record nonstop everything he could with his pencil and watercolors. Soon Casarosa realized that doing a crawl with a group of artists instead of solo was better, and so SketchCrawl became communal. It then became a worldwide event made easy by the SketchCrawl online forum. Chapters have sprung up worldwide in cities such as Hamburg, Florence, Detroit, Tokyo, Berlin, Milan, Seattle, Honolulu, Bangkok, Toronto, Brisbane, Sapporo, Galilee (Israel), Melbourne, Rome, Copenhagen, Vienna, Brussels, Barcelona, Portland, Gustavsberg (Sweden), and more.[1]

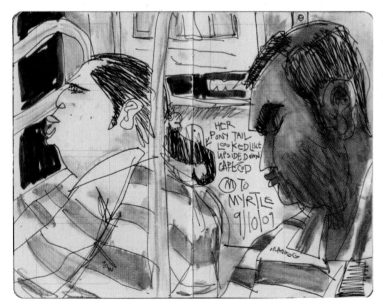

01

URBAN SKETCHERS

Urban Sketchers was founded by Spanish-born illustrator and journalist Gabriel Campanario, a staff artist and blogger at the *Seattle Times*. Campanario initially started his Flickr group to showcase Urban Sketchers. A year later, he expanded the Flickr group to be by invitation only, requiring regular postings and the stories behind the sketches.

Since that time, the blog has allowed people to share their location drawings and others to visit the site for inspiration from the hundreds of contributors on six continents. The blog and its artists have been featured in magazines and newspapers across the globe. Sketches from London, Barcelona, New York, San Francisco, Lisbon, Singapore, and Seoul show everyday life in action, including streetscapes, architecture, and faces. Nina Johansson, one of the Urban Sketchers contributors in Stockholm, notes, "Drawing a city isn't just capturing it on paper; it's really about getting to know it, to feel it, to make it your own."

The group is nonprofit with the goals to organize educational workshops and raise funds for artists' grants and scholarships. They even have a manifesto that defines their mission:

1. We draw on location, indoors or out, capturing what we see from direct observation.

2. Our drawings tell the story of our surroundings, the places we live, and where we travel.

3. Our drawings are a record of time and place.

4. We are truthful to the scenes we witness.

5. We use any kind of media and cherish our individual styles.

6. We support each other and draw together.

7. We share our drawings online.

8. We show the world, one drawing at a time.[2]

Follow the correspondents' own sketch blogs to see the dedication they have for their work in sketching.

02

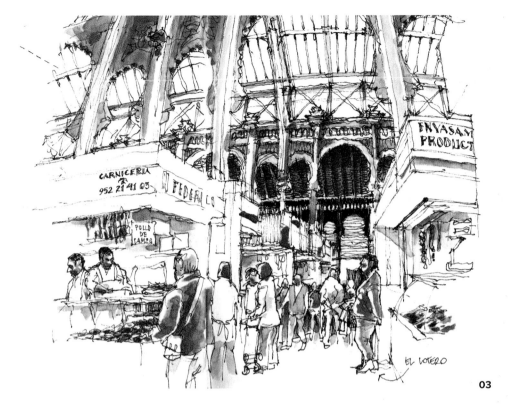

EDUARDO BAJZEK

02 São Paulo, Brazil, Urban Sketchers site banner

LUIS RUIZ

03 Málaga, Spain, *Atarazanas*

SHARI BLAUKOPF

04 Montreal, Canada, *Avenue St. Louis*

03

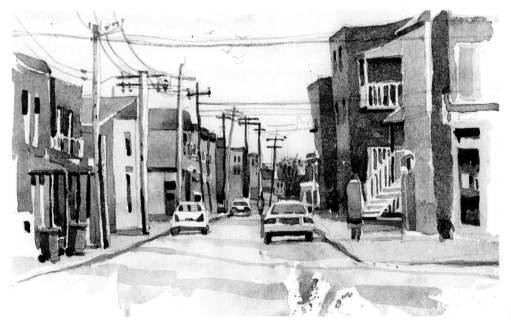

04

05

ILLUSTRATION FRIDAY

Illustration Friday is a weekly drawing challenge and exhibition. A new topic is posted each Friday based on participants' suggestions. They have one week to make their own interpretation of the topic using any medium. Staying involved requires a commitment to contribute each week. The founder of Illustration Friday, Penelope Dullaghan, created very simple rules to become a part of this drawing community. By doing this, she has ensured a regular cycle of imagery and a structured environment for the newcomer, and the consistency of participation is at the heart of this blog's success. Here are Dullaghan's steps:

❶ Illustrate your interpretation of the current week's topic (always viewable on the homepage).

❷ Post your image onto your blog/Flickr/Facebook, etc.

❸ Come back to Illustration Friday and submit your illustration (see the big "Submit Your Illustration" button on the homepage).

❹ Your link will then be added to the participant list and you can check out your artwork along with everyone else's from the IF community![3]

[1] www.sketchcrawl.com, accessed February 20, 2013.

[2] www.urbansketchers.org, accessed February 20, 2013.

ILLUSTRATION FRIDAY

05 Website banner.

JIM MADSEN

06 *Hurry*

IKUKO TAKEUCH

07 *Ocean*

ACKNOWLEDGMENTS

I'm constantly amazed at the enthusiasm expressed by seasoned professionals to collaborate. I found this to be the case with the people I asked to contribute to this book. Through their contributions, they showed how simple things are elegant, and how we all need to rediscover what we have already learned—how to play!

This book came about through the generosity of all the contributors—some I know, some I don't, all admired! Those I don't know could have chosen to ignore my email requests, yet they decided to respond, to follow up with the material requested—or in some cases, something even better! I've had a crash course in what it takes to write a book. The process is like a lot of other things—when done well by others, it looks easier than it really is. While researching material, I became acquainted with so many artists—new to me—and their work. I hope one day to meet them all.

My first thanks goes to designer/illustrator John Foster for recommending this novice to Rockport Publishers. John says that years ago, while he was in college, I visited as a guest artist and gave him a harsh critique. He didn't take it personally and went on to do great things, including authoring five books, running a design firm, and being an all-around great guy. Next thanks go to Emily Potts, my editor at Rockport, for trusting John. She should—they have worked together on numerous projects over the years, and she has been an extraordinarily gentle guide through the process. Where she could, she was hands off— one of the best and scariest things a writer could get from an editor. Then the team at Rockport—Regina Grenier, Cora Hawks, and Betsy Gammons—were always ready to shine a light where needed.

I am also proud of and delighted with the exceptional work of this book's designer and photographer, Bryn Freeman, for her design talent, patience, sharp eye, and unmatched organizational skills. This book (and my life) are all the better for her being involved. I'd also like to thank my graduate students, who were so excited to participate in some of the exercises, and my former undergraduate students, whose class projects I used and who have gone on to be successes in the illustration and design fields. And finally, to Paul Ryan, my husband, who supports me daily (sometimes hourly), makes me laugh, and has taught me how to really look at landscape painting.

CONTRIBUTORS

Minjeong An
Korea
www.myartda.com

Analog Analogue
United States
www.analoganalogue.org

Gerard Armengol
Spain
www.gerardarmengol.com

Zara Atelj/Daily Pattern Project
The Netherlands
www.atelj.ch
www.dailypattern.net

Eduardo Bajzek
Brazil
www.ebbilustracoes.blogspot.co.uk

Scott Bakal
United States
www.scottbakal.com

Sara Barnes
United States
www.saraebarnes.com
workbysaraebarnes.tumblr.com
www.eyra.co

Michael Bartalos
United States
www.michaelbartalos.com
1000 Journal cover art #861-870

Melinda Beck
United States
www.melindabeck.com

Robbi Behr/Idiots'Books
United States
www.idiotsbooks.com

Ana Benaroya
United States
www.anabenaroya.com

Stella Björg
Iceland
www.stellabjorg.com
www.behance.net/stellabjorg

Shari Blaukopf
Canada
www.shariblaukopf.com

BMD Design
France
www.bmddesign.fr

Bomboland
Italy
www.bomboland.com

Stefan G. Bucher/Daily Monster
"Daily Monster" is a registered trademark of
Stefan G. Bucher. All rights reserved.
United States
www.344design.com
www.dailymonster.com

Jude Buffum
United States
www.judebuffum.com

Mariah Burton
Canada
www.mariahburton.com

Gabriel Campanario/Urban Sketchers
United States
blogs.seattletimes.com/seattlesketcher
www.urbansketchers.org

Alison Carmichael
United Kingdom
www.alisoncarmichael.com

Robyn Chachula
©2008 Interweave Press
United States
www.interweave.com

Flora Chang/Happy Doodle Land
United States
www.HappyDoodleLand.com

Jeansoo Chang
United States
jeansoochang.blogspot.com

Alex Citrin
United States
www.alexcitrin.com

Rachael Cole
United States
www.cargocollective.com/rachaelcole
www.rachaelcole.blogspot.com

Jorge Colombo
United States
www.jorgecolombo.com

Eduardo Corral
Mexico
www.micaillustrationpractice.org/students

André da Loba
United States
www.andredaloba.com

Mai Ly Degnan
United States
www.mailyillustration.com

Krissy Diggs
United States
www.krissydiggs.com

Tonia Di Risio
Canada
http://toniadirisio.com

Henrik Drescher and Wu Wing Yee
China
www.hdrescher.com
www.wuwingyee.com

Penelope Dullaghan
United States
www.penelopeillustration.com
www.illustrationfriday.com

Hannah Erhardt
United States
www.hannaherhardt.com

Luci Everett
Australia
www.lucieverett.com

Susan Farrington
United States
www.susanfarrington.com

Lisk Feng
China
lisklisk.tumblr.com

Laura Murphy Frankstone
United States
www.lauralines.com

Bryn Freeman
United States
www.brynfreeman.net

Raoul Gardette
United Kingdom/France
www.etsy.com/shop/raoulgardette

Kim Gim
United States
www.kimberlygim.com

Nicola Ginzel
United States
www.nicolaginzel.com

Carin Goldberg
United States
www.caringoldberg.com

Cristina Guitian
Spain/United Kingdom
www.cristinaguitian.com

Martin Haake
Germany
www.martinhaake.de

Tanya Heidrich
United States
www.flickr.com/tanyaheidrich

Jane Heinrichs
United Kingdom/South Africa
www.janeheinrichs.com

Brockett Horne
United States
www.mica.edu/About_MICA/People/Faculty/
Faculty_List_by_Last_Name/Brockett_Horne.
html

Daniel Horowitz
United States
www.daniel-horowitz.com

House of Illustration
United Kingdom
www.houseofillustration.org.uk

Dingding Hu
China
www.dingdinghu.com

Ashley Jackimowicz
United States
www.artofash.com

Nick Iluzada
United States
www.nickdraws.com

Sarah Jacoby
United States
www.thesarahjacoby.com

Steven Johnson
United States
www.alawishus.com

Lita Judge
United States
www.litajudge.com

Lara Kaminoff
United States
www.laurakaminoff.com

Olena Kassian
Canada
www.olenakassian.com

Zoe Keller
United States
www.zoekeller.com

D.W. Kellogg
© American Antiquarian Society, 2013
United States
www.americanantiquarian.org

Na Kim
United States
www.na-kim.com

Seo Kim
South Korea
www.seokim.com

Richard Kuoch/PodgyPanda
United Kingdom
www.podgypanda.com

Sam Lacombe
United States
www.sams365project.com

Marissa Lanterman
United States
www.marissalanterman.com

Lapin
Spain/France
www.lesillustrationsdelapin.com

Alex Lasher
United States
www.alexlasher.com

Kelly Lasserre
United States
www.kellylasserre.com

Yao Li
United States
www.yaodraws.com

Luciano Lozano
Spain
www.ilustrista.com

Bo Lundberg
Sweden
www.bolundberg.com

Matt Lyon
United Kingdom
www.c8six.com

Emma Maatman
United States
www.emmamaatman.com

Jim Madsen
United States
www.jimmadsen.blogspot.com

Sandie Maxa
United States
www.upwithq.com

Marika McCoola
United States
www.marikamccoola.com

Jacqueline McNally
United States
www.jacquelinemcnally.com

Debbie Millman
United States
www.debbiemillman.com

Anil Mistry
United Kingdom
www.starchild-art.blogspot.com

Eve Mobley
United States
www.behance.net/EveMobley

Valeria Molinari
Venezuela
www.pocketsizedreams.blogspot.com

Stacey Dugan Montebello
United States
http://smontebello.blogspot.com

Nicole Mueller
United States
www.nicolemariemueller.com
www.nicolemariemueller.blogspot.com

Mark Notermann
United States
www.behance.net/notermark

Juan Carlos Vázquez Padilla
Mexico
www.juancarlosvazquez.com

Michael Paulus
United States
www.michaelpaulus.com

Tilly Pelczar/Idiots' Books
United States
www.idiotsbooks.com

Lisa Perrin
United States
www.madebyperrin.com

Amitai Plasse
United States
www.amiplasse.com

Alice Rebecca Potter
United Kingdom
www.alicepotter.co.uk

Margaret Ramsay
United Kingdom
www.magsramsay.co.uk

Mimi Rojanasakul
United States
www.prattgradcomd.com/
jexsted/project/1437/
designer-profile-series-mimi-rojanasakul

Lezli Rubin-Kunda
Canada/Israel
www.lezlirubinkunda.com

Luis Ruiz
Spain
www.luisrpadron.blogspot.com

Paul Ryan
United States
www.paulryan.org

Mark Sanders
United States
www.upwithq.com

Marguerite Sauvage
Australia
www. margueritesauvage.com

Guido Scarabottolo
Italy
www.scarabottolo.com

Alissandra Seelaus
United States
www.madebyalissandra.com

Ward Shelley
United States
www.wardshelley.com

Whitney Sherman
United States
www.whitneysherman.com
www.pbodydsign. com

Mark T. Smith
United States
www.marktsmith.com
1000 Journal #801-810

someguy
United States
www.1000journals.com
www.1001journals.com

Mikkel Sommer
Germany
www.mikkelsommer.com
www.mikkelsommer.blogspot.com

Rich Sparks
United States
www.richsparksillustration.com

Roz Stendahl
United States
www.rozworks.com

Tong Su
Singapore
www.micaillustrationpractice.org/students

Dain Suh
United States
www.dainsuh.com

Matthew Swanson/Idiots'Books
United States
www.idiotsbooks.com

Ikuko Takeuch
United States
the-floweroflife.blogspot.com
www.illustrations.web.fc2.com

Mark Todd
United States
www.marktoddillustration.com

Caroline Tomlinson
United Kingdom
www.carolinetomlinson.com

Nora Truskey
United States
www.noratruskey.com

Katherine Tyrrell
United Kingdom
www.pastelsandpencils.com
makingamark.blogspot.com

Kevin Valente
United States
www.kevinvalente.com

Joan X. Vázquez
Mexico
www.joanxvazquez.com

Paige Vickers
United States
www.paigevickers.com

Chip Wass
United States
www.chipwass.com

Matt Williams
United Kingdom
www.uberkraaft.co.uk

Matt Woodward
United States
www.mattwoodwardart.com

Diyou Wu
China
www.decue.weebly.com

Amanda Yonkers
United States
www.amandayonkers.com

Claire Zitzow
United States
www.clairezitzow.com

Deborah Zlotsky
United States
www.deborahzlotsky.com

Jaime Zollars
United States
www.jaimezollars.com

ABOUT THE AUTHOR

Whitney Sherman is a multifaceted artist. Beyond her career as an award-winning illustrator, she has worked in print design, advertising, package design, and broadcast television, and was trained in photography. As undergraduate Chair of Illustration at the Maryland Institute College of Art (MICA) from 2000 to 2010, she grew the department into the largest at MICA, with innovative interdisciplinary courses that balanced personal expression and authorship within a wide range of markets. She has been co-director of Dolphin Press & Print @ MICA for ten years, and is now director of the MFA in Illustration Practice, a program examining illustration's cultural meaning.

Sherman's national client list has helped her create award-winning illustration and design. Her 1998 Breast Cancer Research Stamp, the first semi-postal issue, has raised more than $70 million for research and is the longest running U.S. postal stamp to date. She is represented nationally by Gerald & Cullen Rapp in New York. Her work has been exhibited worldwide in the Axis Gallery in Tokyo, the Design Museum in London, the Israel Museum in Jerusalem, and various U.S. venues, including the Society of Illustrators Museum of American Illustration in New York, the Art Institute of Chicago, and the Norman Rockwell Museum in Stockbridge, Massachusetts. Sherman's current work includes limited edition houseware designs for Pbody Dsign.

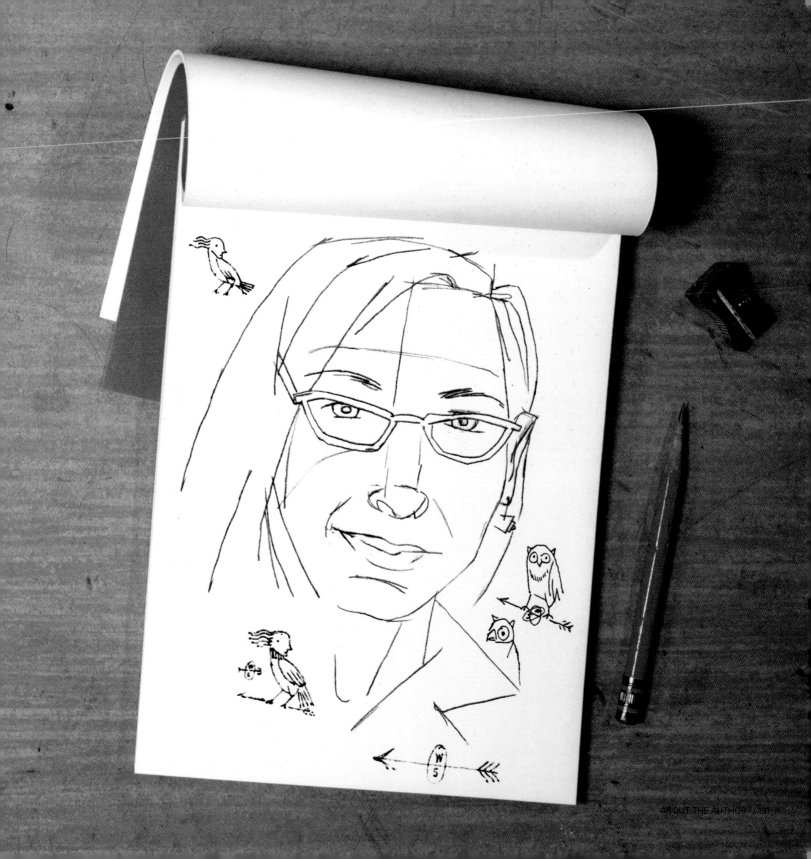